this book is dedicated to the two people who taught me that i was no better or worse than anyone else despite my socio-economic status in life—william (mose) & dorothy (nancy) turner. also, to all of the mcdonalds, past and present; and to the late lottie s. knight and lucille deview, the two women who always took my good and made it great.

Keep loving yourself

journey to the woman i've come to love

affirmations from women who have fallen in love with themselves

blessings

photos by **miki turner**

cover: nnasarawa prempeh, first african american female to receive a degree in metallurgical engineering from mit.

foreword

about 10 years ago i was hanging out with some old high school classmates in cincinnati. we were all in our mid '40s, drinking wine, gossiping about former classmates and wondering what fresh hell lie ahead for us as we approached menopause and all the other absurdities that come along with aging.

i graduated from the school of what will be will be and i'm not really one to stress out over the way i look. but, then, as my friends pointed out, i wasn't aging—at least externally. i've never dyed my hair, been botoxed and there isn't a wrinkle on my face. but even if i had shown the normal signs of aging, i'm pretty sure i wouldn't be freaking out like they were. some were already on the waiting list for cincinnati's top plastic surgeon! this obsession with maintaining their youth made me sad. why couldn't they just accept themselves as the smart, wonderful and beautiful women that they are? a few wrinkles should not affect one's self esteem.

that conversation was actually the genesis for this book.

i needed to know at what point did women fall in love with themselves. initially, this project was called **journey to the woman i will become**. but, after having had some epiphany in the middle of the night, i changed it to **journey to the woman i've come to love.**

my initial plan was to feature celebrities. back in 2006 when i first started this project, i figured that would be the best way to secure an agent and subsequent book deal. but god was like, "uh-uh." he was right. celebrities get their due in spades. i needed to provide a platform for the thousands of wise and wonderful nameless women whose voices needed to be heard, too.

i guarantee you'll be glad i took the road less traveled.

but even though just about everyone on the planet told me this was a great idea, it took me six years to finally get it all done. there were many stops and starts along the way. sometimes i just got bored with it, sometimes it frightened me. and there were other times when life's distractions just got in the way—death, unemployment, love, travel, chronic laziness. you know the drill.

that, too, however, was part of some divine plan.

had i finished this in a year or less, i would have missed out on: angela davis, leymah gbowee, jane lynch, miss rosa, nnasarawa prempeh, diane nash, myrlie evers-williams, marie therese durocher, laurel hill-simeone, perle meneses nunez, naomi judd, amina ziadi, angelina jolie and so many others. i call them my random happy accidents.

the truth is, had laurel holloman not gotten all up in my grill on a balmy summer night in venice, italy this year, i might have gone another six years just adding more people. there are still so many women whose journeys i want to share.

can you spell s-e-q-u-e-l?

i'm often asked why i didn't include myself. that's simple, this is my journey. i've never been more in love with myself than i am right now.

at what point did you fall in love with yourself?

alba francesca

producer/quilter
los feliz, ca

"i don't think i've ever not loved or liked myself. my parents and my family were all very encouraging when i was a child. i was lucky because no one ever put me down. there was no negativity. we all supported each other and that's the way it's always been with me."

about this photo: alba was actually suggested to me by a mutual friend. she invited me to her condo in los feliz, where she has an amazing collection of antique toys and other memorabilia. as a former actress she knows about setting scenes and did so here—perfectly.

journey to the woman i've come to love

alystyre julian

screenwriter/poet
new york, ny

"when i first felt all my cells vibrate in a yoga class at 18."

about this photo: al is a friend of a friend and when i saw her i got really angry. not at her, at myself. i had made the stupid decision to travel without my cameras. i'd just returned from lugging them around overseas and felt my body needed a break. thank goodness the good people at sony gave me a cybershot compact during the spider-man junket. this photo isn't the best quality because of the limitations of an entry-level point-and-shoot, but it did capture the essence of al at a jamaican restaurant in soho in 2012.

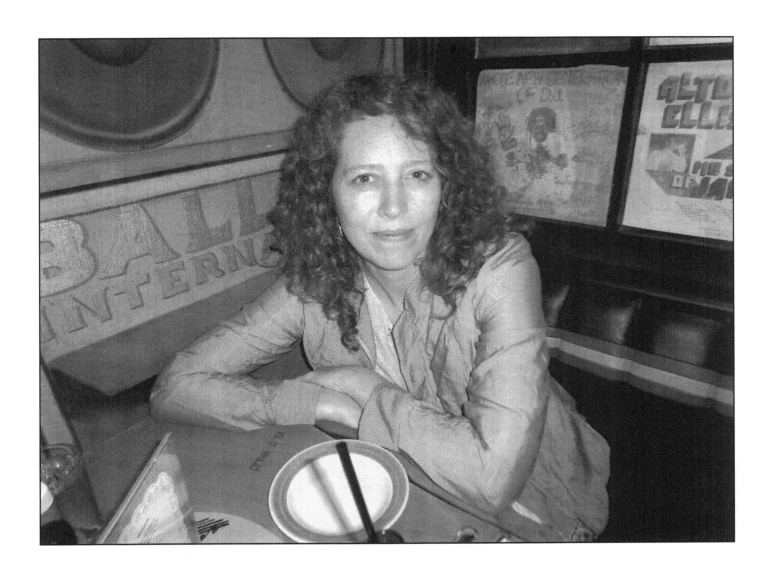

amal el atrache

comedienne/actress
casablanca, morocco

"i've always felt like i love myself the most when someone was in love with me."

about this photo: *i met amal during a lunch gathering at a beachfront restaurant in casablanca in 2011. with those glasses and expressive eyes, how could i resist not including her. also, i think a lot of us can relate to her response.*

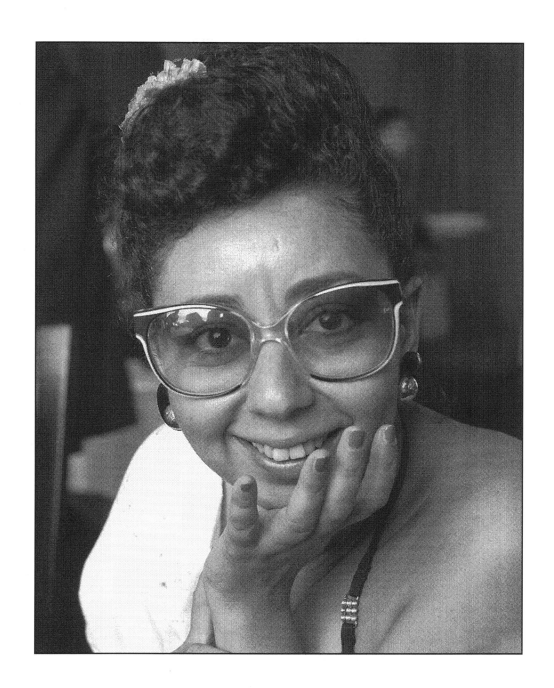

amina ziadi

creative services
rabat, morocco

"i started to love myself when i realized what it meant to be a woman. i loved myself even more when i started to have my children at age 16. i never cared what people said, i was just always confident in myself."

about this photo: *after hearing her daughter talk about her mom's journey i knew i wanted amina in the book. logistically, however, that proved to be too challenging time-wise. when i returned to morocco six months later, i got in touch with her daughter again and her mom drove for more than an hour to meet me. i love the intensity in this photo. she's had some knocks in life but god's grace has sustained her.*

journey to the woman i've come to love

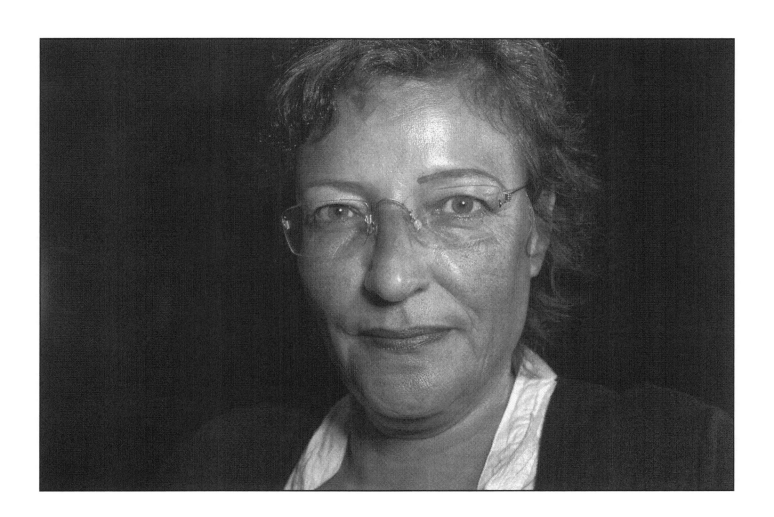

angela davis

author/educator/activist
berkeley, ca

"well, you know, i guess i would say i fell in love with myself when i realized that my community was more important than me as an individual. i've come to recognize the absolute importance of community and collective struggle. and, nothing i have accomplished, nothing significant, has ever been simply the result of my own skills, my own aspirations. it's always been in the context of a larger community."

about this photo: *what can i say? this was the opportunity of a lifetime! other than martin luther king jr., dr. davis was the most iconic figure of my childhood. i got sent home in seventh grade for wearing a "free angela" t-shirt. i wish i had gotten a more artsy shot, but i think this one perfectly illustrates who she is at 68. it was shot in pasadena, 2012. i'm still basking in the coolness of that moment.*

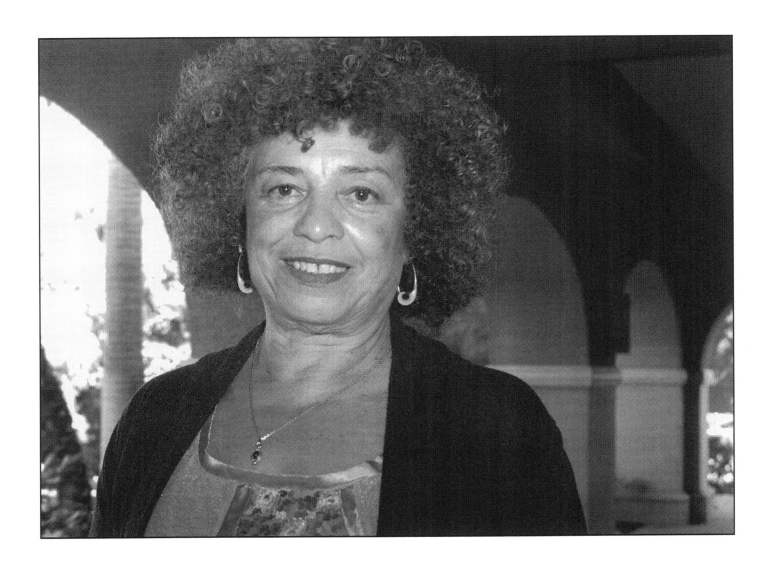

angelina jolie

oscar-winning actress/philanthropist
the world

"i don't know that anyone ever completely does. i think i changed when i became a parent. it's not that you're in love, but you feel a sense of pride in who you are because at least you think you're doing something right—you're doing that right."

about this photo: *the question was asked in paris and this shot was taken just off the red carpet at the 2012 oscars. i had another shot that angie had posed for but there was just something so fetching about this one. she was about to enter the theater and she was looking back to see where her man was. that's love.*

journey to the woman i've come to love

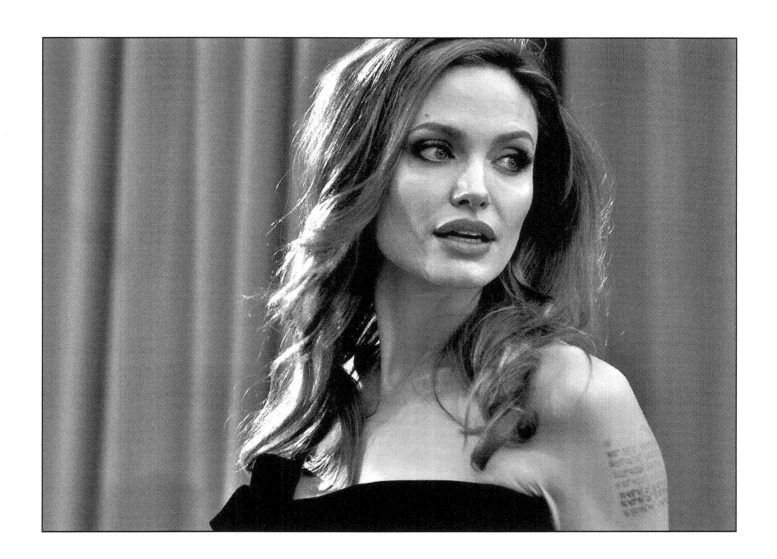

barbara toney richman

nurse
wyoming, oh

"there was no specific moment, no significant event, just a gradual 'feeling comfortable' with myself that began a few (or so) years ago. when i began to see myself not as someone's daughter, not as someone's wife, not as someone's mother, but as a unique woman with more strengths than weaknesses, more perfections than flaws, more confidence than doubt, more dreams than regrets."

about this photo: *every time i go home to cincinnati barb's house is one of my first stops. we've been friends since junior high and she has been incredibly helpful to my mom when i'm not there. that's one of the reasons why she's in the book. i wasn't going to include any close friends or family because inevitably someone's feelings would get hurt if they weren't included. that said, barb almost didn't make the cut because i hated the first series of photos we shot in '08. she was uncomfortable in front of the camera and it showed in every frame. but one night last year we were sitting on her back porch and the light was so wonderful i couldn't resist trying again. magic. when i saw this shot, i said, "she's back in the book."*

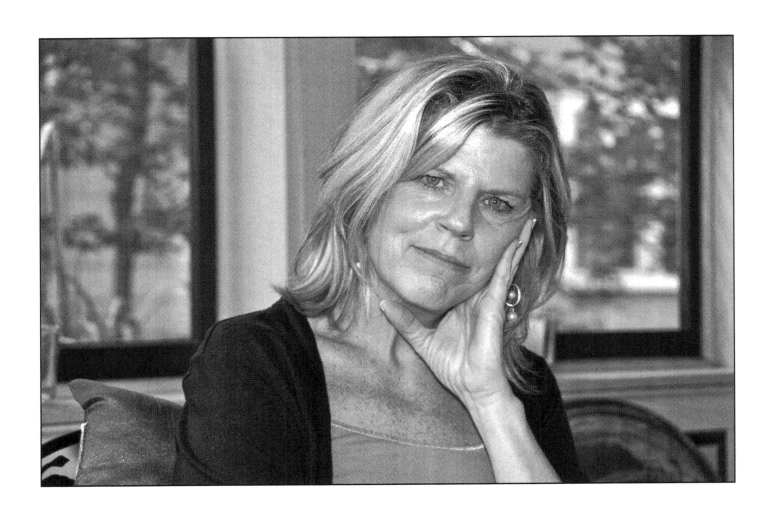

carlota espinosa

dotcom executive
hollywood, ca

"i think it happened when i started listening to my gut and my instinct. every time i do that it never sways me the wrong way. when i don't, that's when i get into trouble. it's something i think i learned from my mother. i've become her in so many ways and that's a good thing because she's a remarkable woman. so, i'm falling in love with myself as i'm becoming more like my mother."

about this photo: *carlota and i first met in 2009 at a party in the hollywood hills where she lives. she reminded me so much of jackie kennedy onassis. i loved her spirit and asked her to be a part of the book. we had two sessions at her home. i chose this shot because it was the one that truly looked like her—and jackie o.*

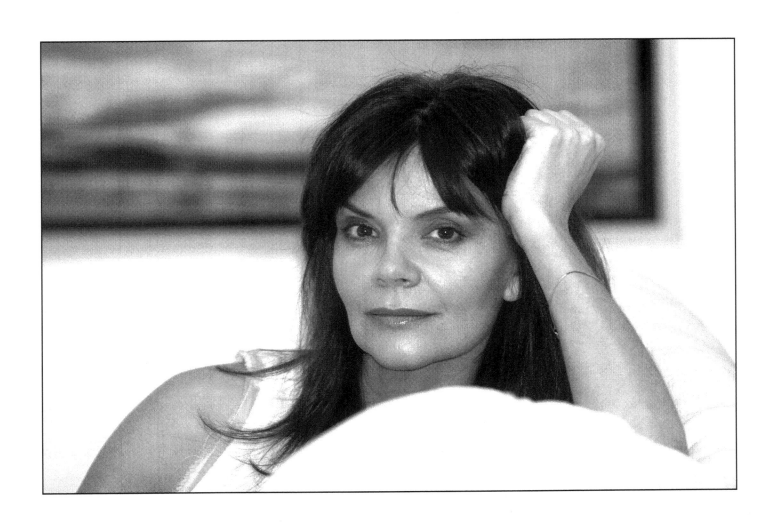

cori murray

magazine editor
brooklyn, ny

"i remember going to dinner with some high school friends. i started singing. i said, 'i used to love this song.' my friend, vera, said, 'and we loved you for it.' that made me realize that all of those years that i felt corny or felt like the white black-girl or felt out of place, the people who were close to me loved me for who i was. in turn, that made me realize that i was ok with me. later, after i ended a relationship that could have turned out to be abusive, i joined a hard core military-style boot camp and was asked 'why do you want to do this, what are your goals?' i looked at the lady and said, 'honestly, i just want to be able to defend myself if i need to.' when i graduated, i felt like the queen of sheba. i was in love with myself physically; i was in love with myself mentally. it just really made me feel empowered."

about this photo: this was taken at cori's home in brooklyn in 2009. she wanted to include her infant daughter in the shots and this was the one that just bounced off the screen. i don't think i've ever seen a more tender mother-daughter moment recorded in black-and-white.

journey to the woman i've come to love

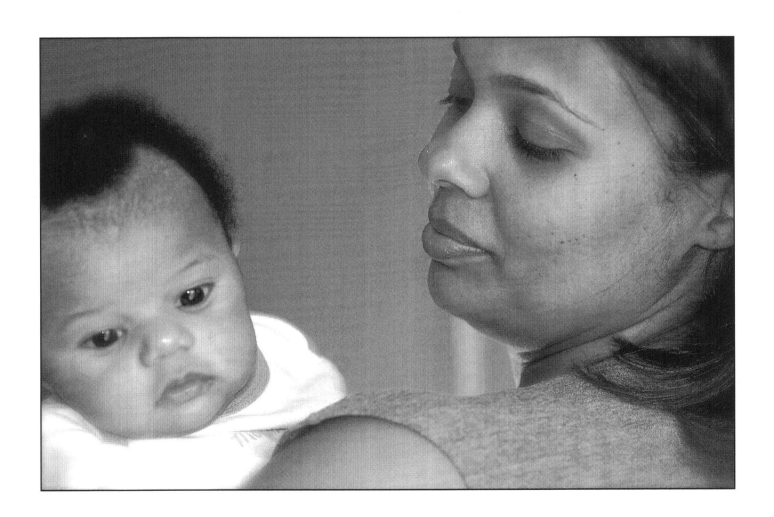

cynthia deitle

fbi agent
washington, dc

"it was third grade. i was a little tomboy and i wanted to be a cop. my father said 'you can't be a cop, you have to be a lawyer.' i said, 'i know that's what you are dad, but i don't even know what that is.' he said, 'you know what…? you can go to law school and then join the fbi.' my dad said that the fbi was the best cop job ever, so that's what i did. it never occurred to me that i couldn't because i was female. it never occurred to me that i would be walking around in high heels and still shoot a gun.

i was lucky enough to know what i wanted to do at a young age. my parents supported that and encouraged me to be a strong woman and that did a lot for my self-esteem."

about this photo: *i became fascinated with cynthia not only because of her back story but because she had dedicated her life trying to solve cold case civil rights murders. that was way cool. also, i had never seen an fbi agent who looked like her. i shot this in 2010 outside the langham hotel in pasadena.*

dana delany

actress
los angeles, ca

"this year, for the first time in my life, i can genuinely say that i am totally happy by myself. i have no need to be in a relationship. if it happens, that's great. if it doesn't, i'm totally happy. it has taken turning 54 (in 2010) to get here."

about this photo: i met dana at a party in 2010 and everything about her suggested she was a woman who had become comfortable in her skin for quite a while. she had on very little makeup, spoke to everyone and seemed totally at ease with herself and the environment. a year later when i showed her the shot i was going to use in the book, unlike many actors, she was pleased with it. no photoshop requests, no grimaces. she simply said: "works for me!"

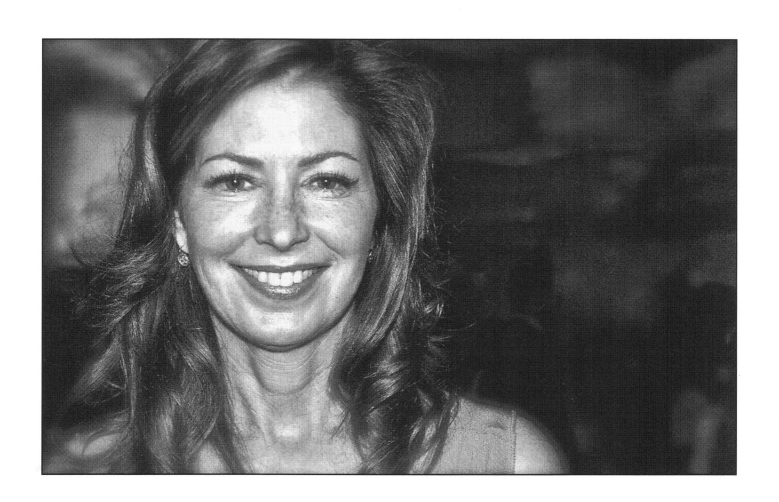

deborah thomas

psychologist
sydney, australia

"it was just a moment after having been a psychologist for about 10 years. a client, who had been pretty troubled when she came to see me, looked at me after about a five-year therapy and said, 'i can't believe how much i've changed since i've been seeing you.' it was the realization that i could actually do something to really help someone. i started to love myself when i realized i had value."

about this photo: *deborah and i met through social media. on one of her visits to l.a. she wanted to explore the l.a. i knew and loved so i took her to leimert park, the african american cultural center of the city. our mutual curiosity about each other led to this shot in 2010.*

della reese

actress/singer/pastor
los angeles, ca

"i don't think there was a time when i wasn't. that i could open my mouth and this sound came out impressed me. and at that time i was a lyric soprano so i could sing with the birds. i liked it. it was good. i don't know that i ever stopped to figure out who i was. i have always lived in the moment to do what it was that was happening for me at that time."

about this photo: *one opportunity, one shot. i got lucky. this was taken in the green room at the beverly hilton hotel.*

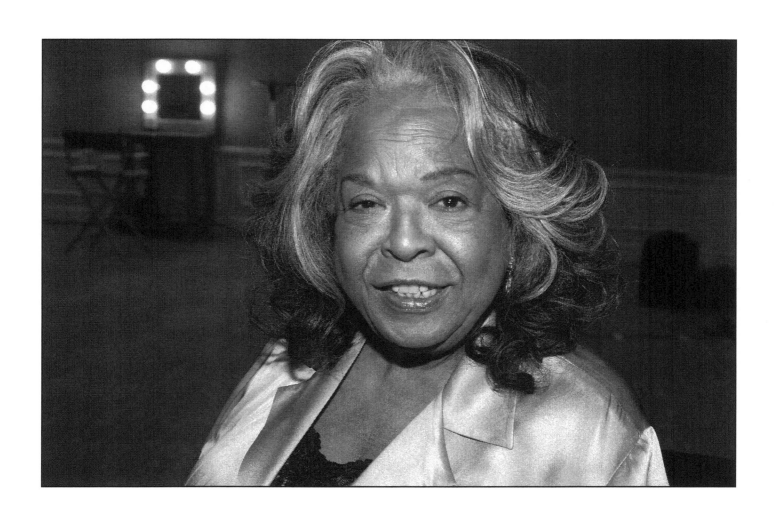

diane nash

freedom rider/civil rights icon
chicago, il

"i think it's been continuous from the time i can remember. as i learned and had experiences i became more and more confident and comfortable. and at this point—age 76—i'm pretty comfortable. the movement had a great role in my identity. segregation was so humiliating that every time i complied with it, it felt like i was agreeing that i was too inferior to go through front doors or ride in the front of the bus like everyone else. it was really important to my development and my own self-image to resist and to change it."

about this photo: *back in the day diane nash was undeniably one of the most beautiful women in the movement. age has simply enhanced her inner and outer beauty. i'm never really star-struck, but any time i've been blessed enough to meet someone who took a beating so i can do what i do, i am just awed by their presence. this 2010 photo at the langham hotel in pasadena is my love letter to ms. nash.*

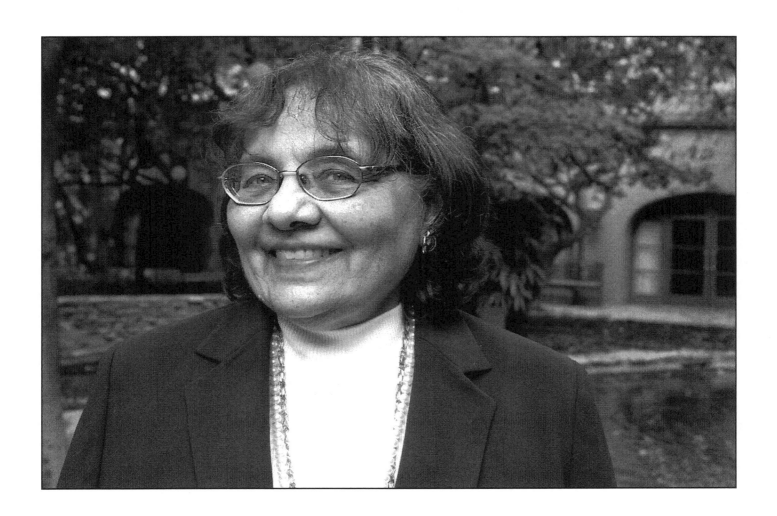

dinah veeris

herbalist
curacao

"i'm always in love with myself because we need to love ourselves to be able to love each other. so, i like myself, i work for myself and i pay very close attention to my health so that i can take care of myself—my body and my spirit."

about this photo: *i visited curacao in the spring of 2012 and insisted on stopping by dinah's herb farm after hearing about it. she's got something for all your ailments! i actually wanted to shoot her inside with all the herbs but there were too many tourists buzzing around so we stepped outside and captured the spirit of a woman who is living well.*

journey to the woman i've come to love

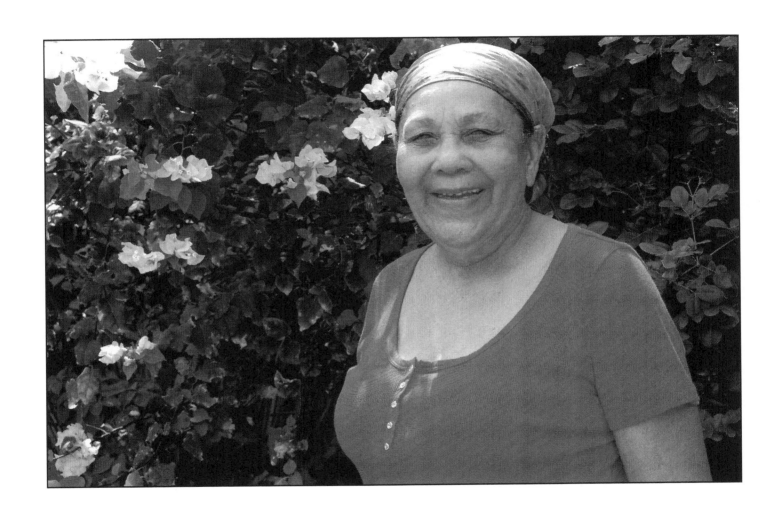

donzaleigh abernathy

actress/author
beverly hills, ca

"when my appendix ruptured, they called my parents in and told them i might not make it. but i kept telling them 'i'm going to live, i'm going to live.' i was 11 and i loved that i was alive. i loved my spirit because at that point i knew it was about spirit and not about body. i knew that i was born into this life for a reason. my whole attitude changed. i was already a little alpha child but i loved myself and i loved my life and loved the second chance that i was being given."

about this photo: *after about six months of trying to set this up, i met donzaleigh at her home in beverly hills and we shot her outside at a nearby park. it was funny because she was ringing up all of these celebrities to tell them about the book and that they should be in it! that included her mother, juanita, the widow of civil rights icon dr. ralph abernathy. she wasn't feeling great that day but was absolutely radiant.*

journey to the woman i've come to love

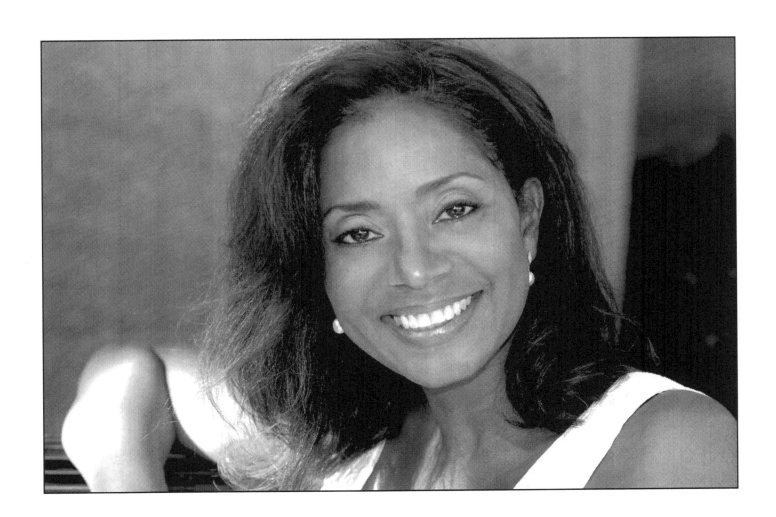

elisa gaffney stadler

homemaker
ealing, england

"i think i still consider myself a work in progress. i think you get different women who do different things. i've pursued a more traditional path. i married quite young. i started a family, so something had to give. i gave up work after having my second child and consequently the reins to my career and some of my self-esteem. i don't regret that for one minute. invariably, women give so much of themselves. but as a result you submerge your desires as you tend to the pressing needs of rearing families. now that my children are older, i am rediscovering myself a bit and that's particularly lovely."

about this photo: *elisa was actually my first model when i became truly interested in photography. we met at boston university where we were both grad students studying journalism and i would shoot her every chance i got. back then she had these amazing red schoolboy glasses and a thick mane of deep auburn hair. i thought she was simply gorgeous. we lost touch shortly after she returned to london, married and began having children. it took me 22 years to find her again and when we met for lunch in london we were both in awe of each other's paths. this shot was taken in the living room of her home in ealing. i like it because it reflects both her wisdom and her kindness.*

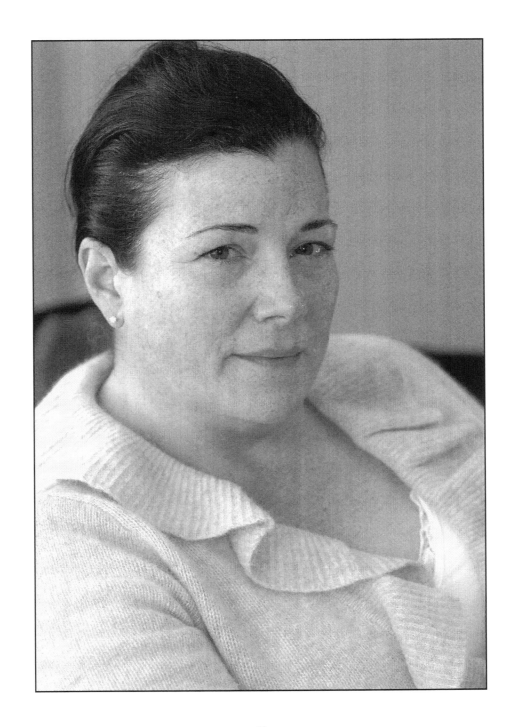

evelyn braxton

reality tv star/life coach
atlanta, ga

"when i went through my divorce, my self-esteem was on the ground. so, i had to work with myself every day to let me know that i'm beautiful, i'm wonderful and that i may not be the prettiest woman in the world, but i'm in the top two! it's called loving oneself and there's nothing wrong with that. i love me. i am in love with me. you have to tell yourself that and not depend on anyone else to do so."

about this photo: i met mrs. braxton for the first time two years ago in pasadena during an interview with her daughters for their new reality show. i actually hadn't planned on including her in the book but i thought her response to the question was so powerful that i had to include her. plus, she photographed really well!

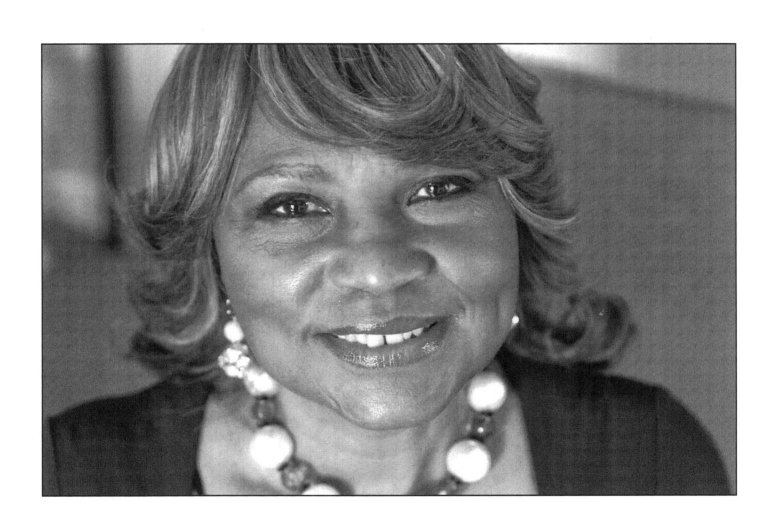

felicity huffman

actress
los angeles, ca

"i fell in love with my body after i had children, which is odd because my body was not pretty after i had children. it wasn't just 'look, it miraculously just made this other person and how fantastic.' i remember looking at it after i got out of the shower and it looked like a bag of doorknobs. but i remember, for some reason, i thought, 'that's beautiful.' i don't know where it came from, it's kind of the grace of god, but i do remember the critical mass shifted in that regard."

about this photo: *i took this during a set visit to "desperate housewives" in 2010. felicity made a face in the only shot in which she was looking at me. i would have loved to have used that but i don't think she would have appreciated that! but when i showed her this one a year later, she approved. "that's me," she said.*

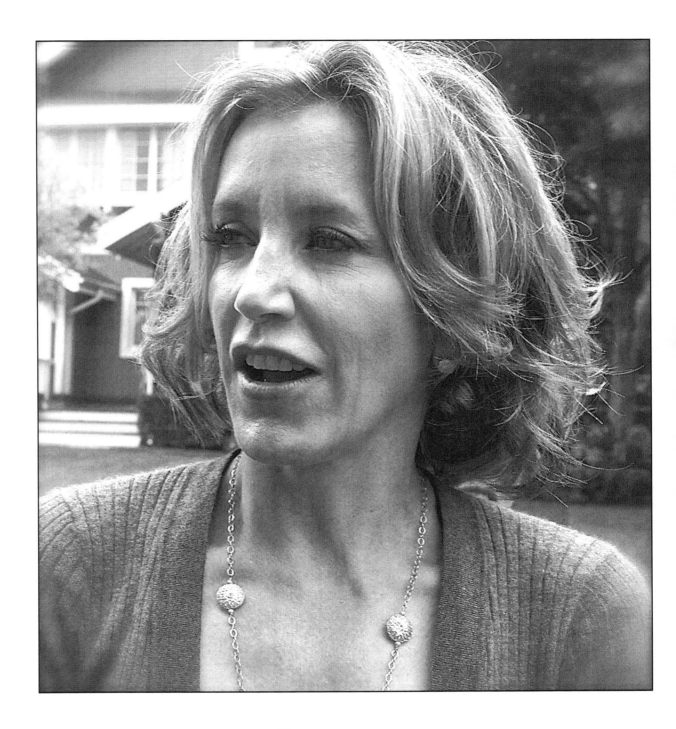

gladys knight

grammy-winning singer
atlanta, ga

"to be very honest with you i had the greatest parents. and they taught us from the very beginning because of the way they loved us, to love ourselves. and, i think since we're into this industrial movement and we have so many people working now—both parents—that we don't have that in the home any more. we've got too many kids out there trying to find it on their own. they just don't know where to go and who they are. i'm blessed that i learned early on."

about this photo: *i actually stalked ms. knight for about two hours at the beverly hilton hotel in 2012. again, one opportunity, one shot. i don't think she's capable of not looking good in front of the camera.*

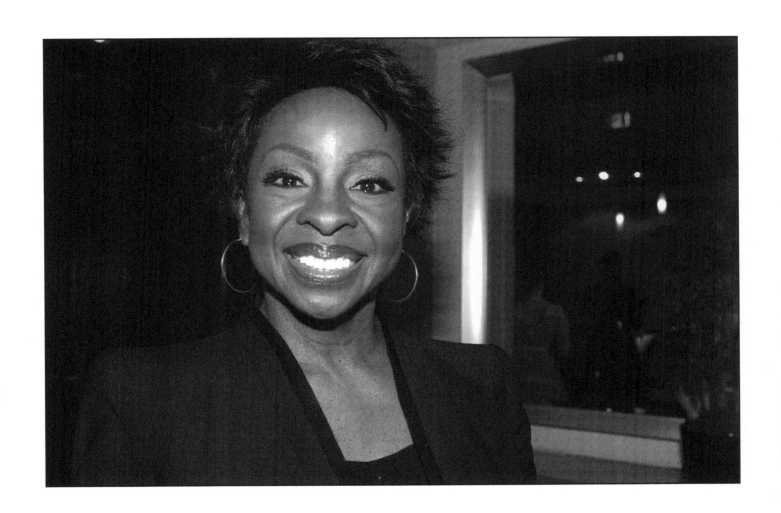

gloria loring

singer/actress/author
los angeles, ca

"i think i arrived in this life mostly in a state of enthusiasm and love. then some events caused me to doubt myself. this falling-in-love-with-self business has been, for me, somewhat like an arranged marriage. i was stuck with myself and it took a while for a deep and abiding love to blossom. about 20 years ago, in the midst of despair, i sent out a prayer asking for help. within a short period of time i met my meditation teacher. i've learned to forgive my frailties and mistakes, which has accelerated my life's learning curve. the greatest gift in growing to love and appreciate one's self is the cessation of self-imposed suffering and projected chaos. i am endlessly grateful for less drama!"

about this photo: *ms. loring and i met at lacma in '09. i had always wanted to shoot someone under the gaslights. she's a pro and knows how to work the camera but this shot makes her look a little more vulnerable than the others. sweet and sexy, still.*

journey to the woman i've come to love

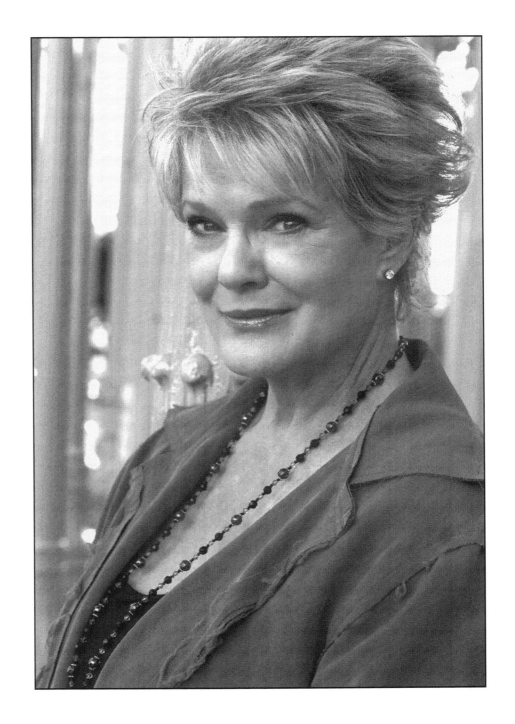

gloria steinem

magazine founder/author/feminist
new york, ny

"never actually, i'm still working on it! that's a good question. i think only after i was about 16. i think age helped because i stopped second-guessing myself."

about this photo: *another icon, another great response. this was also one of those times in which i had about five seconds to get the shot. this was taken just outside the beverly hilton hotel in 2011.*

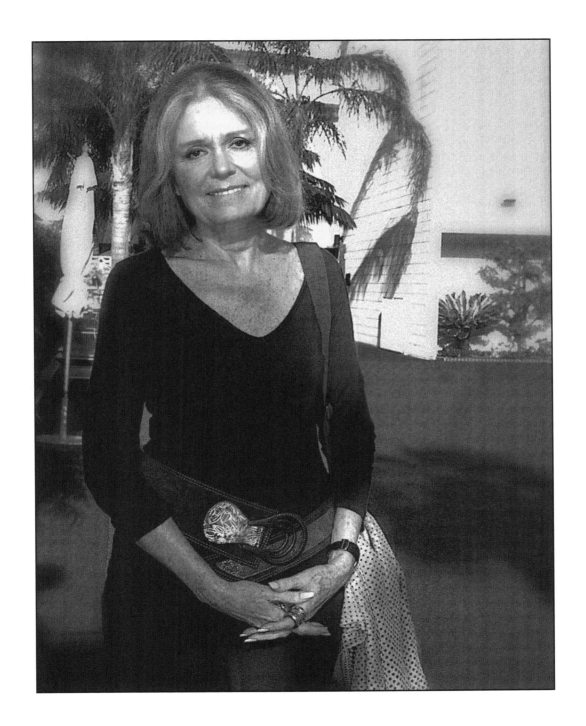

gwenda ansell

author/journalist/critic/lecturer
johannesburg, south africa

"i can't remember a time when i didn't love myself. it probably means that i had a great upbringing–particularly by my mother. my parents were very aspirational so i was never treated as a girl. i was never treated as a daughter. i was treated like a child who would hopefully achieve good things in the future. i think a lot of women are treated too much as a 'daughter' so 'we can't expect too much. she's probably going to get married' and so on. for whatever reason my parents never treated me that way and i'm forever grateful for it."

about this photo: *gwen and i had met several times at the cape town jazz festival in south africa. i'd always found her a bit intriguing but she always had a lot of people around her. one day in 2010 i caught her alone and took this shot."*

halle berry

oscar-winning actress
los angeles, ca

"i would probably say that i fell in love with myself after my second divorce. i think it was at that time that i realized what i was made of. i realized that i was enough all by myself. i was in control of my happiness and i should not put that burden on anyone else. that's when i started to fall in love with myself. i realized that, as this life goes, it's about me and i better start loving me."

about this photo: *i was going to use a much more glamorous shot of halle i'd taken at a charity event in '09. but this one, shot in 2011, just felt more personal, more halle. despite all of her professional accolades, she's still my homie from cleveland, who is now so much more comfortable in her skin than she was when i first met her. it's been lovely watching her grow.*

journey to the woman i've come to love

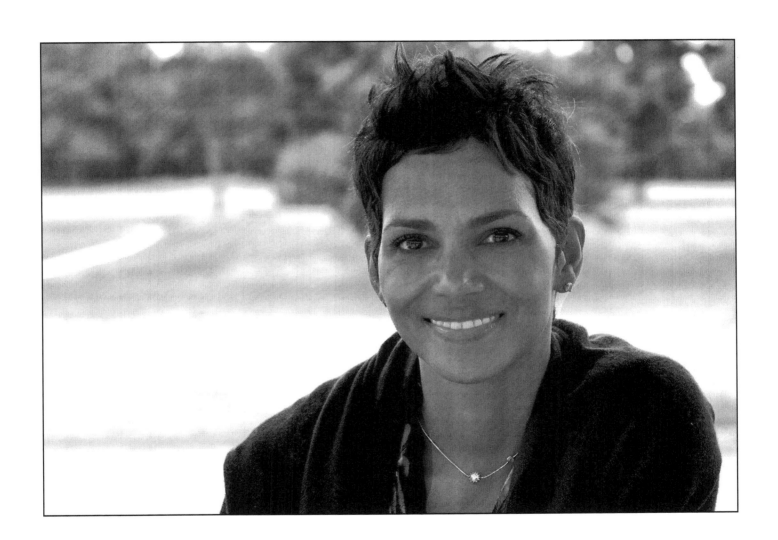

isabelle van rolleghem

ceo
montpellier, france

"i gradually became conscious that the love my parents lavished on me was something special and this gave me a sense of self-respect and pride that developed into an important place in my thinking and credo. i realized, without the need for it to be voiced, that my parents had confidence in me and that i couldn't fail in life – not just that i couldn't let them down but that i was equipped with a positive attitude that could only help me along the road into the unknown future. it was probably as a direct result of this realization that i first fell in love with myself."

about this photo: *this was shot at a café in st. germain in 2012. i'd just met isabelle after months of communicating via email and everything about her just seemed so healthy and confident. her smile was warm and infectious.*

journey to the woman i've come to love

jane lynch

actress
los angeles, ca

"i was about 38 and i took all the monologues i had done in sketch comedy and i put them together in a show. i rented a theater and invited people. i made a poster and, as i was picking up the flyers for the opening, i thought, 'what is that smell?' i thought it was the printer or something. i realized it was me and it was fear. i don't know if you've ever smelled fear—it's sour and awful. i was scared to death but i went up there and did this show, kind of all by myself—i had a couple of other people in it—but i made every aspect of it happen. i walked out and i did it. i created an entity and i had never done that before. i fell in love with myself that night. i was out of my body—literally going: 'you rock!'"

about this photo: *i recorded jane's response to the question back in '09. she didn't have a publicist then and told me i could call the network to set up the photo. i knew that wasn't going to work—especially after "glee" took off. so, a year later i forced myself to cover the red carpet at a network party in pasadena and asked her to pose for this shot just after she'd come off the carpet. i really like it because it kind of illustrates how far she's come in life and her career.*

journey to the woman i've come to love

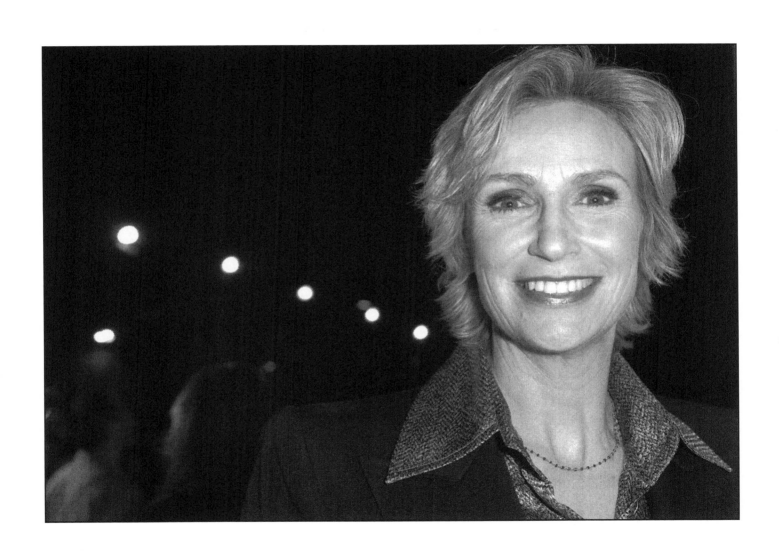

jane smith

nurse
cincinnati, oh

"it really started for me when i started this job. helping people is the most rewarding, awesome job ever. i love coming to work."

about this photo: *my mom was in cincinnati's university hospital with a scratched cornea and jane was her very caring nurse. on this day in 2009, the light was just hitting her right and I took this shot as she was making her rounds.*

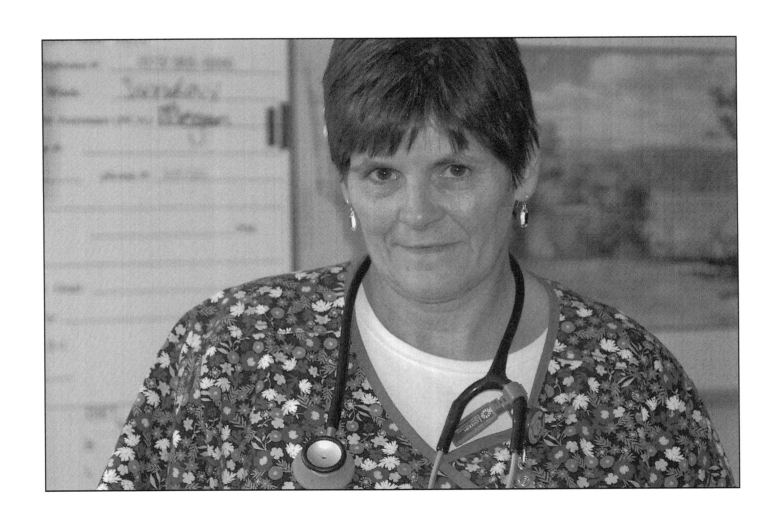

jenifer lewis

actress/singer
los angeles, ca

"when i took responsibility for every choice that i had made, that i was making and that i was going to make. responsibility. it was after 17 years of therapy actually. i've been very level and very happy for the past 10 years."

about this photo: *jenifer is one of those rare entertainers who can sing, dance, act and make you laugh so hard you'll need stitches afterward. i caught up with her last year in beverly hills where we took this fetching shot. this would make the late gay-iris parker so proud.*

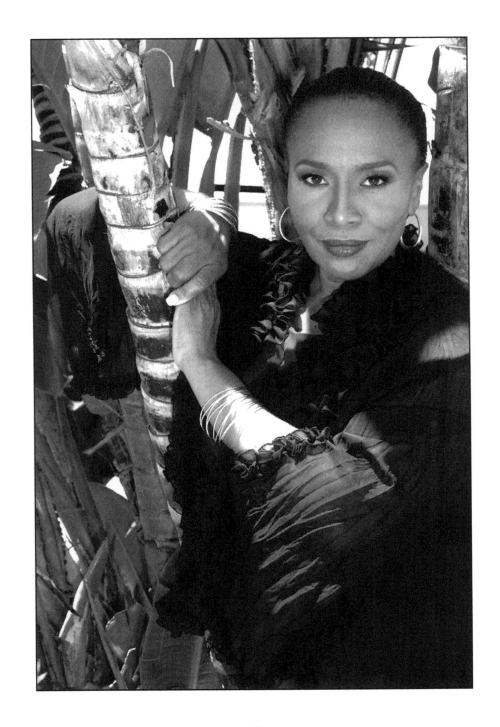

jenny burney

property manager
los angeles, ca

"i fell in love with myself once i stopped judging others. at that point i didn't care who was judging me and it allowed me to open myself up."

about this photo: *jenny and i met via twitter. she manages "the" property in hollywood with great views, so we shot this on the roof of her building in the summer of 2012. that's her maltese, bogie, in her arms.*

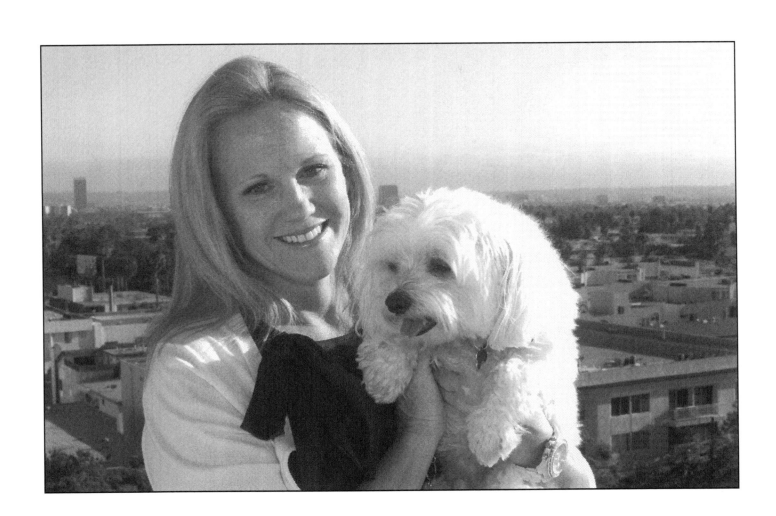

jo-ann huff albers

retired college dean/journalist
cincinnati, oh

"when i was picked to portray an angel in the second-grade play at elmwood (cincinnati) elementary school. i was given wings to wear."

about this photo: *jo-ann gave me my first job in journalism, so she was a natural choice to honor in this book. this photo was taken this year just after her bible study class at her church in lockland, oh.*

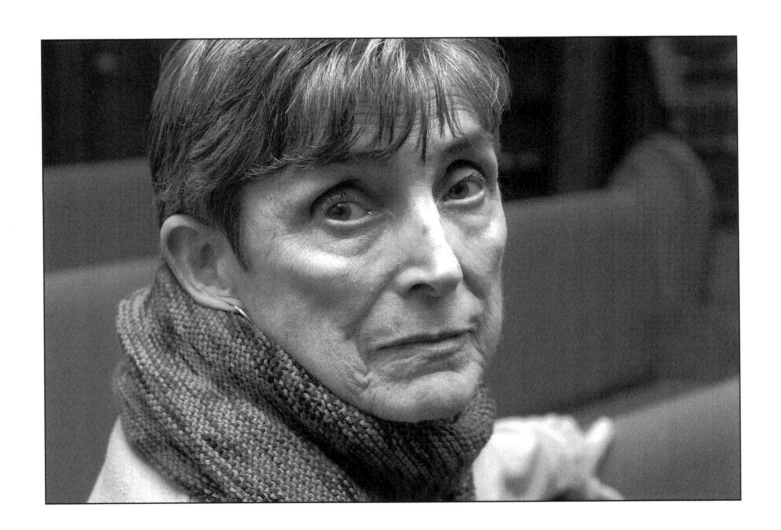

joan otomo-corgel

periodontist
manhattan beach, ca

"at the age of 5 years and 2 months, i raced quarter midgets (small cars). after asking my dad why i got to be the one who got picked to race them, he said, 'you are special.' that was the first time i loved myself."

about this photo: *dr. o is one of the reasons why i still have teeth. although i hadn't seen her in years, i remembered she used to always tell me great stories about her family whenever she was trying to salvage my diseased gums. i kind of wanted to shoot her in her work environment but she suggested that we meet at her manhattan beach home on her day off. that was last year and none of the exterior shots were really working well because the wind was blowing and her hair was all over the place. we went inside and caught the money shot.*

journey to the woman i've come to love

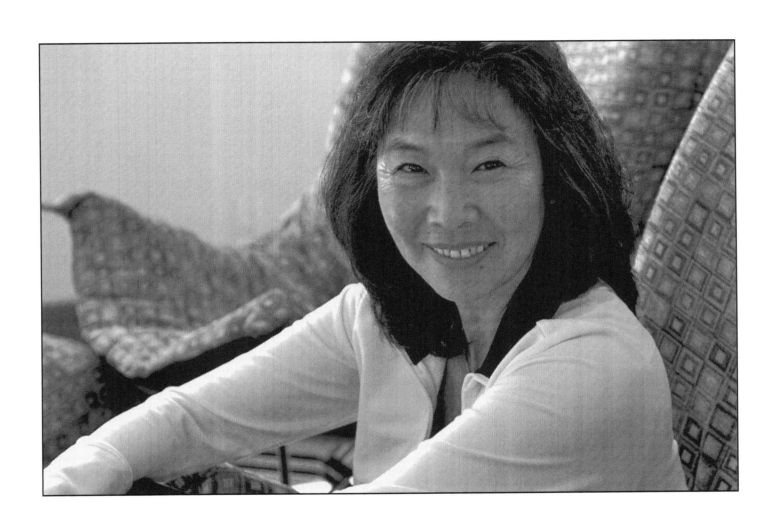

joan trumpauer mulholland

freedom rider/teacher
washington, d.c.

"i think i might have been bullheaded enough that i always did love myself. i could pretty much out-wrestle or go faster on my bike than any guy in the neighborhood and as a kid held my own—surprisingly."

about this photo: *when i met joan i instantly fell in love with the history i saw in her face. she'd fought in a few wars and emerged a stronger woman. that's always the goal. i put her in a garden setting to illustrate the contrast between her past and present in 2010.*

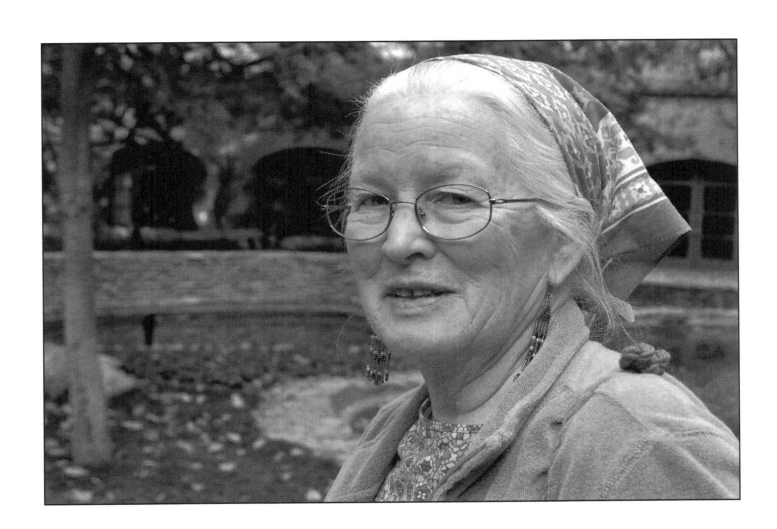

judith jamison

retired artistic director of the alvin ailey american dance theatre
new york, ny

"i don't feel comfortable in my skin all the time, but when you get ready to go on stage, you better know who you are. by the time you finish doing the genius work of an alvin ailey or a katherine dunham or a robert battle, then you come to know who you are. it's the spirit. dance is about spirit. it's not just about dance. it was when i was performing that i really started to realize that the temple was within me. i call it spiritual reciprocity. my spirit is full and i just have to keep reminding myself that god never leaves you. you're always stepping away from your maker, from your creator, but they're really inside of you. that's when you come into that wellness within yourself."

about this photo: *the first time i ever saw ms. jamison was back in the mid-'80s when i was living in new york and working in times square. she was entering 1500 broadway and she wasn't really walking, it was almost as if she were gliding into the building like a swan. i caught up with her again in 2010 as she was being honored at an event in l.a. she was just as graceful—even though she had to tell me to stop taking her picture! i can't really explain why this shot is my favorite. it just is.*

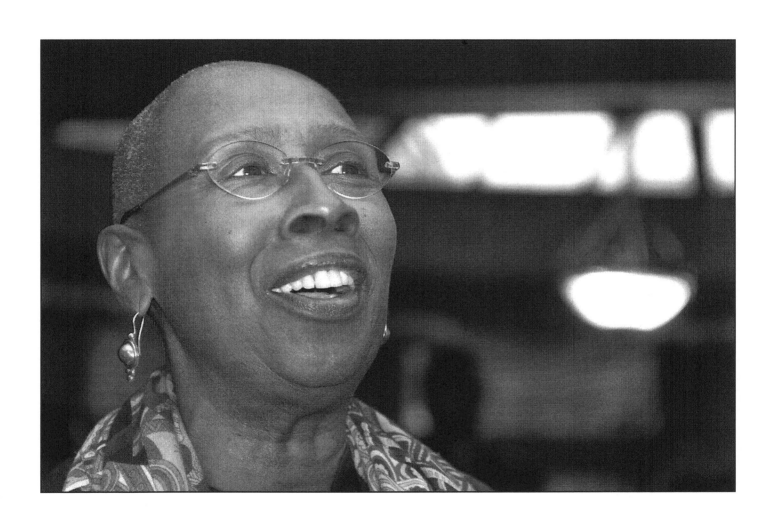

kathleen mcghee-anderson

tv writer/producer/playwright
venice beach, ca

"i didn't begin to fall in love with myself until i fully realized that true beauty is internal. when i finally embraced who i was, not how i looked, or what job i was doing, then i began to feel truly alive and valuable. and, even more, beautiful. i've come to understand that 'to thine own self be true' is much more than a quote. it rings sweet and true like a crystal bell. i live life embracing my flaws and those of others. i love the person i've become and i can see beauty in everyone!

about this photo: *i've been a huge admirer of kathleen's work for years so she was one of the people i wanted in the book early on. it took a while but we finally made it happen on the venice beach boardwalk in 2011.*

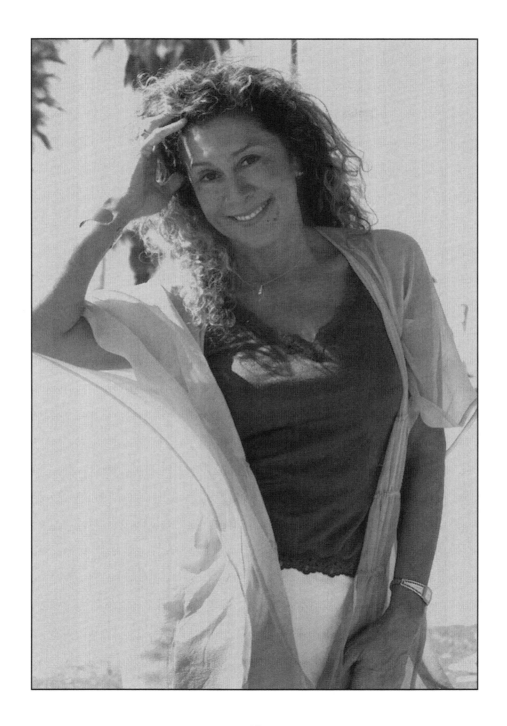

kristie fujiyama kosmides

artist
los angeles, ca

"i started to love the woman that i am when i appreciated that it is a god-given gift that i open every day."

about this photo: *kristie was recommended to me by another artist in 2009. she was somewhat shy in front of the camera, and our little shoot at lacma (los angeles county museum of art) turned into quite the adventure. i wanted to shoot her in the sculpture garden at 10 a.m. but it didn't open up until noon. we had to settle for the courtyard.*

journey to the woman i've come to love

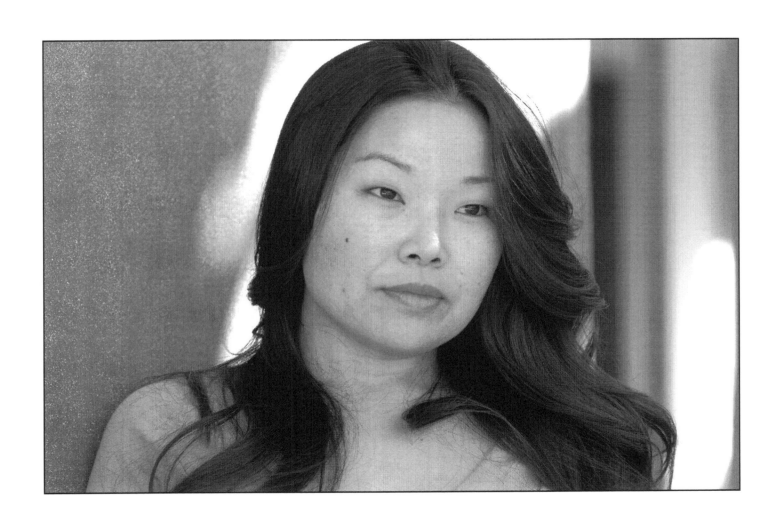

kristin davis

actress
los angeles, ca

"it had a lot to do with growing up in my family. i can't really pinpoint a time because they've always been very supportive although, being an actress, it's easy to wallow in your own insecurities. my parents were always pushing me to be the best and supporting me, even when i wasn't, so that really helps raise your self-esteem and allows you to embrace yourself."

about this photo: *again, this was a situation in which i had several posed shots that really weren't very good. i overlooked this one initially but then thought the shadowing was very artsy and cool.*

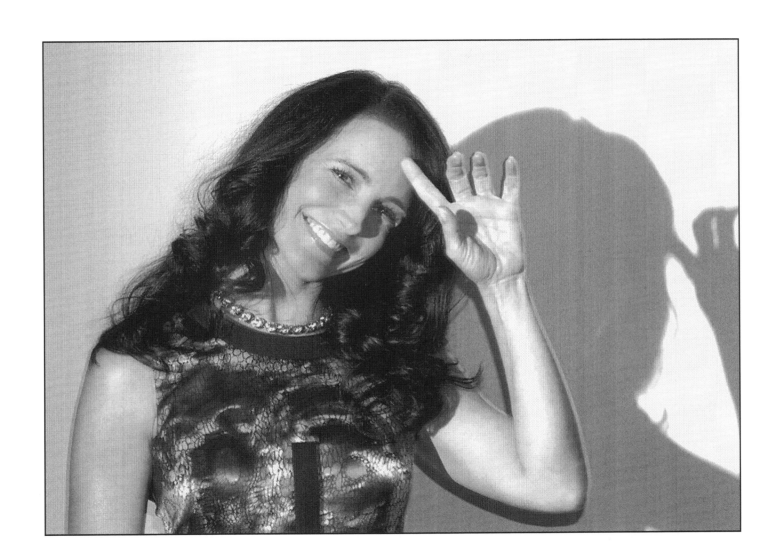

laurel hill-simeone

counselor/volunteer/advocate
raleigh, nc

"it was when i went back to college and i had a course on women and women from all over the world did the whole course. i was 37. every class there was a different woman talking about women's issues. i was newly divorced, really scared, and really fragile. they empowered me. that's when i started seeing myself in a different light."

about this photo: *mrs. simeone is one of the coolest peeps i know. one day we were all sitting around a rented house in venice, ca. in 2011, and it occurred to me she needed to be a part of this journey. she's really into her grandkids and asked to be photographed with them. this is a photo for the ages. it validates the work for me.*

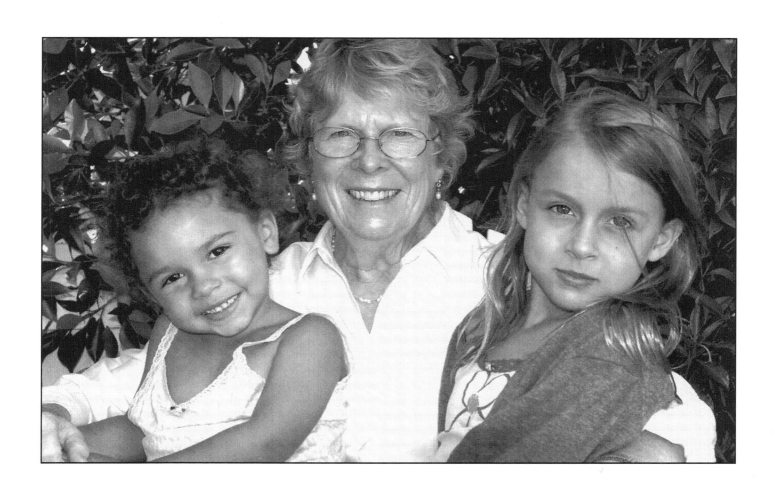

laurel holloman

actress/artist
los angeles, ca

"it happened when i made the decision to appear partially nude on television [the l word, season 2, 2004]. i was six months pregnant. i was puffy and i struggled with gestational diabetes. as an actress you're always worrying about weight and how you look. that decision made me drop all of my vanity. i started to see myself differently. i don't know why, but i felt like it happened then. it was a big step that i also wanted to make for my daughter. i let myself be who i was... loving myself. you should just be who you are and not worry about all the other noise."

about this photo: *laurel and i met at a press event and soon discovered we had some things in common. about four months later i approached her people about the book and was told she'd meet me in malibu. we got so engrossed in girl talk during our first meeting that we never got around to shooting. a week later we met at little dune beach but i didn't really think those shots captured her. the next week she brought along her then 1-year-old daughter nala and we got some incredible stuff. a year later, however, we were shooting headshots at her home in the hills and that stuff was just incredible. i was going to use one of those until i shot her painting in her studio near venice beach. this shot, albeit a happy accident as she was looking down in between frames, was actually used as the promotional photo for her art exhibit in venice, italy in july, 2012. it was a hard decision but i opted to swap the other one out for this one as she has moved on from that period in her life. this is who she is today.*

journey to the woman i've come to love

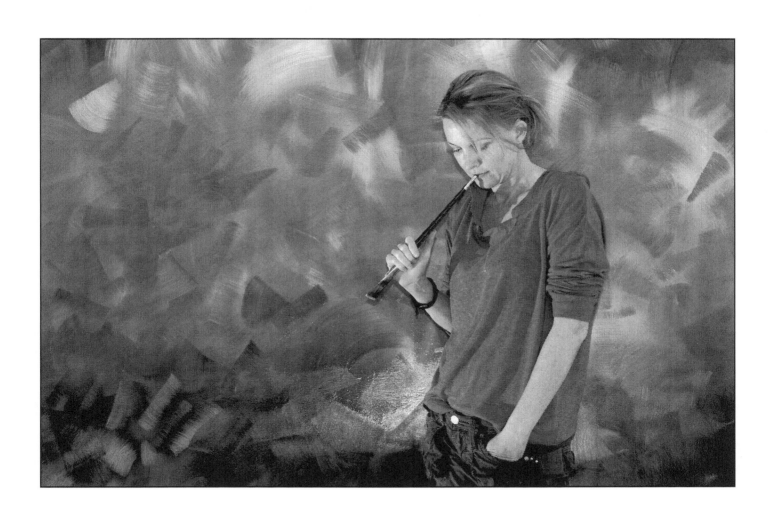

leslie uggams

singer/actress
new york, ny

"i have loved myself from the time i was a child because my father said to me, 'yes, you can. don't let anybody tell you that you can't.' so, all my life, i walked into the room thinking, 'oh, how fortunate you people are—i am here!' [laughs] and that's the way i've always carried myself!"

about this photo: *i caught up with ms. uggams backstage at the pasadena playhouse after a rehearsal for her one-woman show in 2011. once you get past how great she looks for her age, you just get caught up in her aura. this photo tells me that she's achieved total balance in her life."*

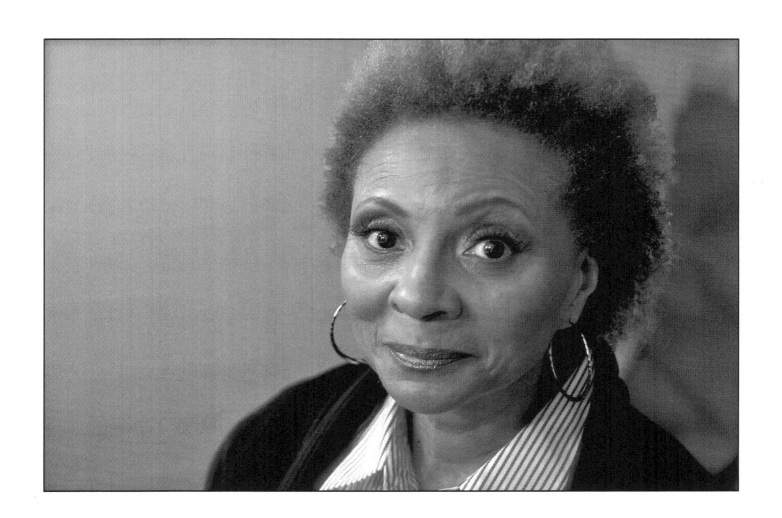

lethe ward

minister/business owner
los angeles, ca

"when i felt loved by god i realized i was fearfully and wonderfully made. i was so tall and different from my family when i was growing up. i felt like the ugly duckling and i hated my mouth the most! i was brutally teased about the size of my lips and i hated to smile. that was until god loved me and confirmed my beauty. this picture accentuates everything i had hated about myself before i realized that i was fearfully and wonderfully made. god kissed those big thick lips of mine and i was never the same again!"

about this photo: *ironically, i would not have chosen this frame out of the hundreds i shot at lethe's 50th birthday party in 2010 at the getty museum. but i can't argue with her logic. her quote says it all.*

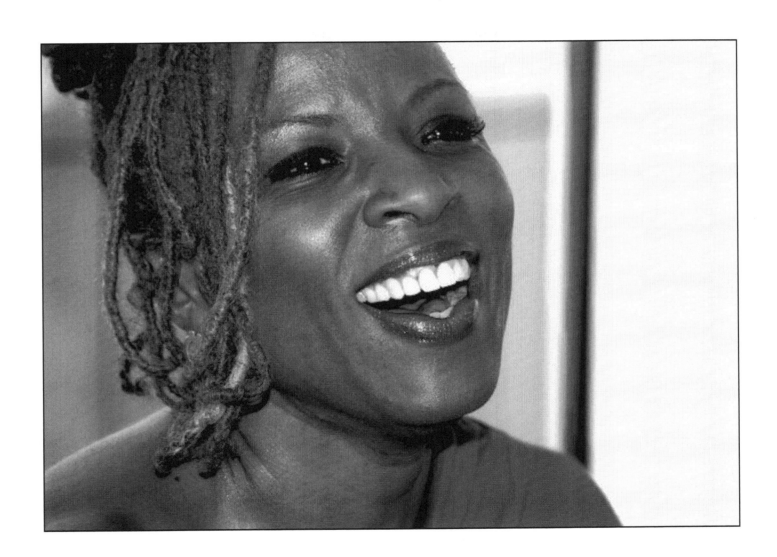

leymah gbowee

liberian activist/nobel peace prize winner 2011
liberia

"not to sound egotistical or narcissistic, but i think that, after all that i went through, being able to look back and see myself here—it's like patting yourself on the back and saying, you did it or you're doing it and you should love yourself for that."

about this photo: *prior to july of 2011 i had never heard of leymah, but, after hearing her powerful story, i knew she'd be a great add for the book. she is. i love, too, that she was wearing her native garb at a five-star beverly hills hotel. i probably could have gotten some better shots but girlfriend had just gotten off a 15-hour flight and was exhausted.*

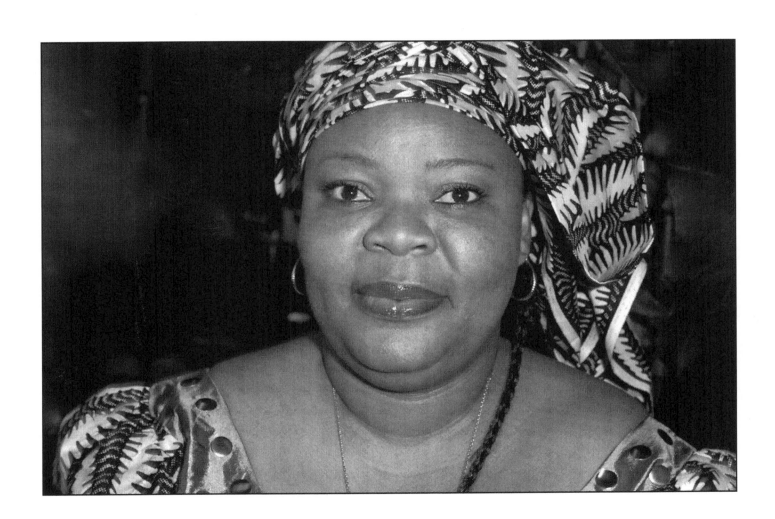

linda evans

actress/author
rainier, wa

"it's been since i left 'dynasty.'" everyone says 'why did you leave this town?' i left hollywood because i wanted to get away from the obvious, which was 'oh, she's a star, this, this and this…' i had success, i had fame, i had money and i was loved by a lot of people in the world. and i thought, there's something missing. there's got to be something else to life than this. i wanted to find out the meaning of life–to me i found out i loved myself. that's the key. we don't need anything outside of ourselves as long as we make that relationship inside of ourselves."

about this photo: who didn't love audra barkley or crystal carrington? so naturally i approached linda about being in the book when i bumped into her two years ago. i only shot about five good frames of her but this was my favorite even though it's so cliché. it looks as though you can look at her eyes and see the soul of a woman who is so grateful to have survived it all and happy to have found her true and contented self.

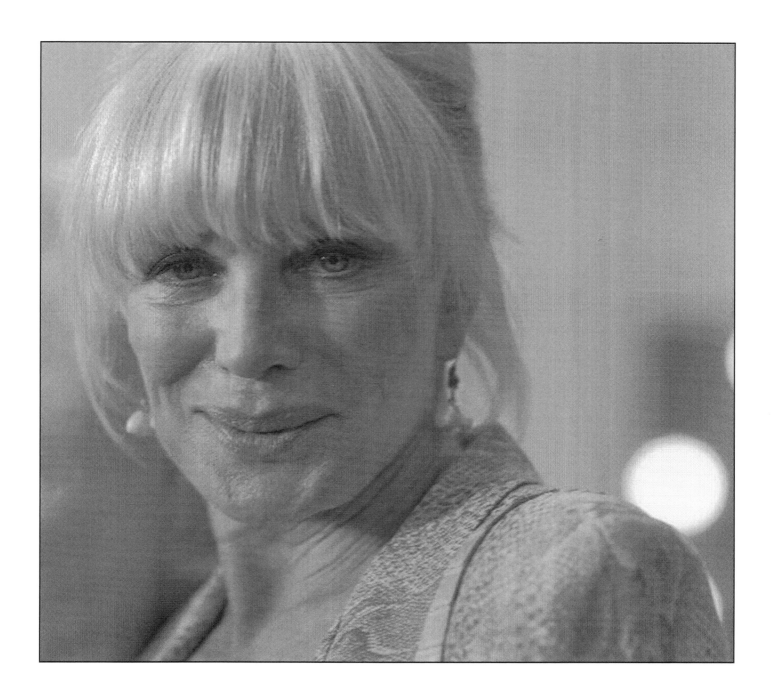

lira

singer
johannesburg, south africa

"i fell in love with myself very late in my life in my opinion. i was in my late '20s and it dawned on me that i cannot carry on in this life almost resenting how i look or not being happy with being how tall i am. you know, it just seemed like it was madness to carry on like this. so, i began to really settle into my skin, to say, 'this is it. it doesn't get any better. this is it so get comfortable and start loving this.' the transformation you go through is powerful. you become fully feminine and it just becomes beautiful being in this skin. i can't help it now. i love being a woman. i love being an african woman because i have fully learned to exist within myself and it's just wonderful."

about this photo: *there are some people the camera just loves. lira is one of those people. her strength, her pride and her spirit are simply mesmerizing. i shot her on a summer day in brentwood, ca. 2012. even though she was thousands of miles away from her birthplace, she seemed quite at home in this botanical setting.*

journey to the woman i've come to love

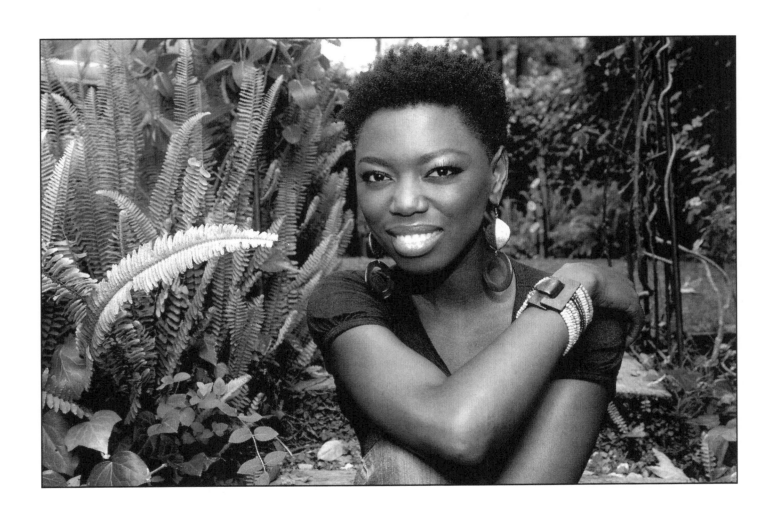

lisa ling

broadcast journalist
los angeles, ca

"i am constantly trying to fall in love with myself. i'm getting better but i need constant reminders to do so."

about this photo: this is really one of those times i wish i could have captured the subject in the comfort of her own home. but, sometimes you just have to go the gorilla route and get what you get. i caught lisa arriving at a pasadena hotel in 2010.

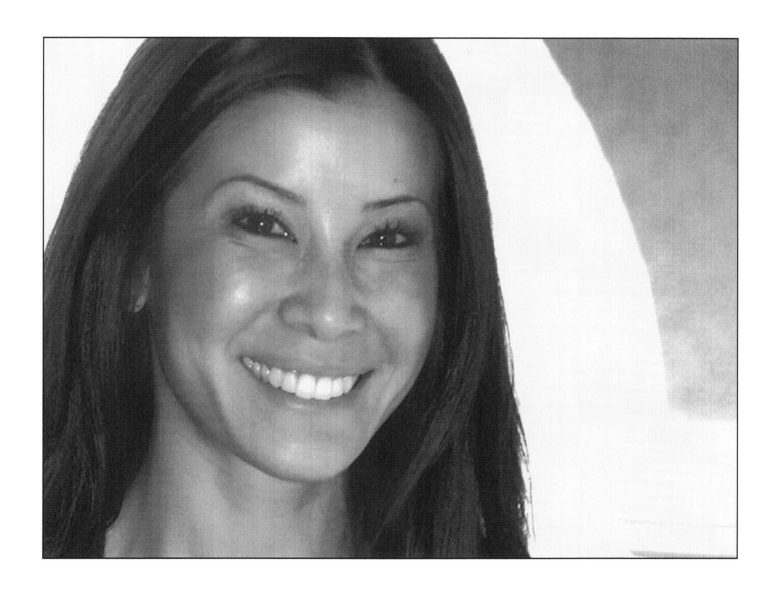

lisa meyers johnson

corporate consultant
los angeles, ca

"i think it's been a work in progress for me. i have periods of loving myself and treating myself well and periods of forgetting how to do that. i think nothing makes you mature and makes you know yourself better than having a baby. it just puts everything in perspective. i re-fell in love with myself once i had my daughter. i started really getting into the motherhood thing and seeing that i'm actually kind of good at it."

about this photo: *lisa and i met during the '90s when she was working with her now father-in-law, earvin "magic" johnson. she was simply delightful. she moved to new york and we lost touch until she befriended me on facebook. this shot was taken when in 2009 at her home in marina del rey. her daughter was about a year old. i loved that they were both beaming!*

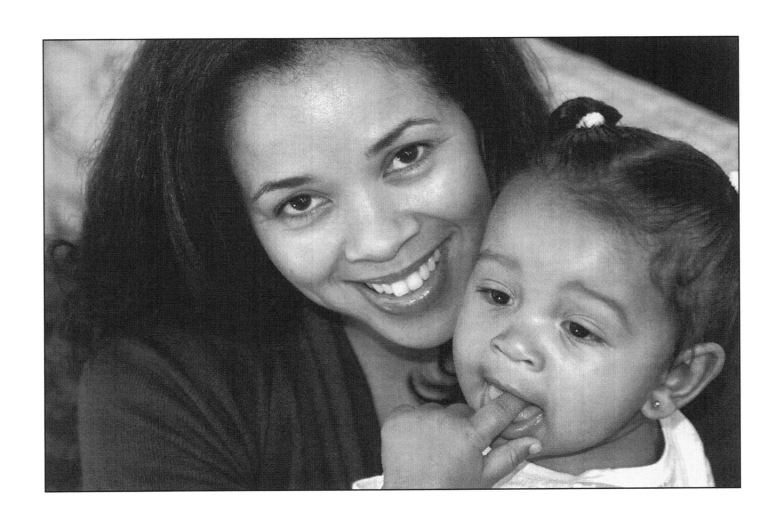

lisa vidal

actress
los angeles, ca

"i do agree that you have to love yourself to be a happy person. i think that the first time i overcame real conflict and difficulty in my life—and i rose up and still was what i thought was a good person—i loved myself. it happened to me when i was a teenager. my parents moved us from a very nice diverse neighborhood into a very not diverse neighborhood. i dealt with a lot of racism and it was hard. i pushed through that and came out the other side ok."

about this photo: *this was taken on the set of the event in 2011, a show that lisa was starring in opposite blair underwood. he was the first latino president and she was his wife.*

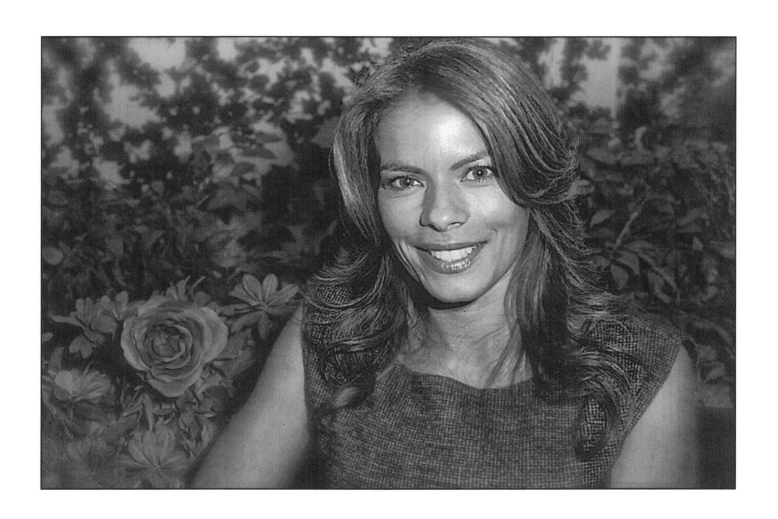

marcy depina

promoter/publicist/tv host
new york, ny

"it started when i had my son because suddenly i realized that if i really wanted to convey a woman's worth to him, what women really stand for and what the beauty of a woman was, i had to be a strong, confident woman. once i made the decision to give birth i actually remember the exact moment of feeling my hips spread and feeling his body come out of me. i thought, 'my body is incredible.' if i can do this, i can do anything."

about this photo: *this was taken in 2011 at a hotel in rabat, morocco. the fullness of marcy is captured here. she is deep and introspective and warm and accommodating. those are all traits that a good mother should have.*

journey to the woman i've come to love

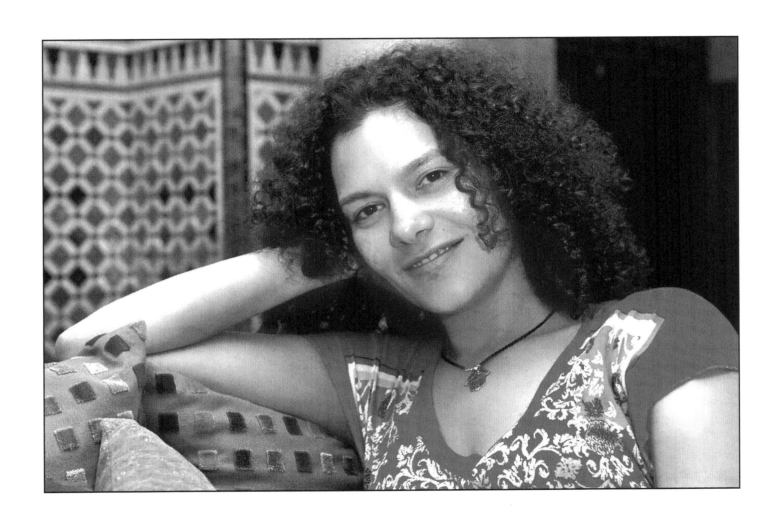

marie therese durocher

social networker
paris, france

"i first had to learn to love myself. my mother passed at a young age, then my father sometime later, i was the only one i could count on. the tragedies: war, loss and deception. the glories: my children, grandchildren and a long healthy life to enjoy them. i realized i was so fortunate to have had wonderful parents and guidance and to have seen so much in life. i began loving me for what i had become and for loving life. the rest is what you see…the cutest french-vietnamese woman, 5-foot-2 in heels and botox free!"

about this photo: *this was about madame durocher's face, spirit and presence. she was the shortest person in the room yet commanded the most attention and respect. it seemed so fitting at laurel holloman's paris exhibition in april 2012 that i would catch the woman who helped make it happen with a glass of champagne in her hand. it was her world and she knew it.*

journey to the woman i've come to love

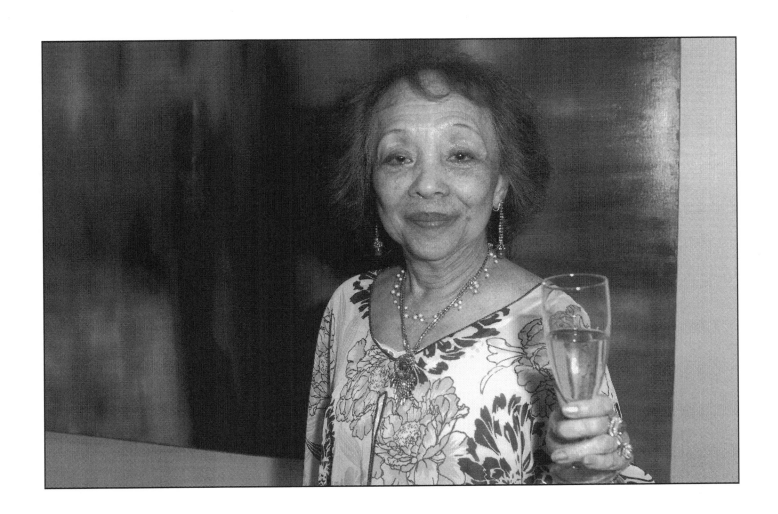

marion jones

olympic gold medalist/pro basketball player/author/mentor
austin, tx

"i certainly think it's a journey. i don't know, at any point, where you're totally 100-percent comfortable. i just think as you progress in life you get more and more comfortable. i'm starting to figure things out and put things together. you certainly have to go through trials and tribulations to really get a true idea of who you are. when life is good and it's all handed to you and you really don't have to work to see who you are, it's not a true reflection."

about this photo: *i first met marion when i was a sportswriter and she was playing for north carolina in the 1994 ncaa basketball championship. her tenacity back then was undeniable. we met up again in '09 in pasadena when she was promoting an espn film john singleton had done on her. this was after she had been stripped of her gold medals, after the trial, after the divorce and the birth of her kids. she seemed a lot less intense. i think i captured a woman who had owned the truth of her past and moved on.*

journey to the woman i've come to love

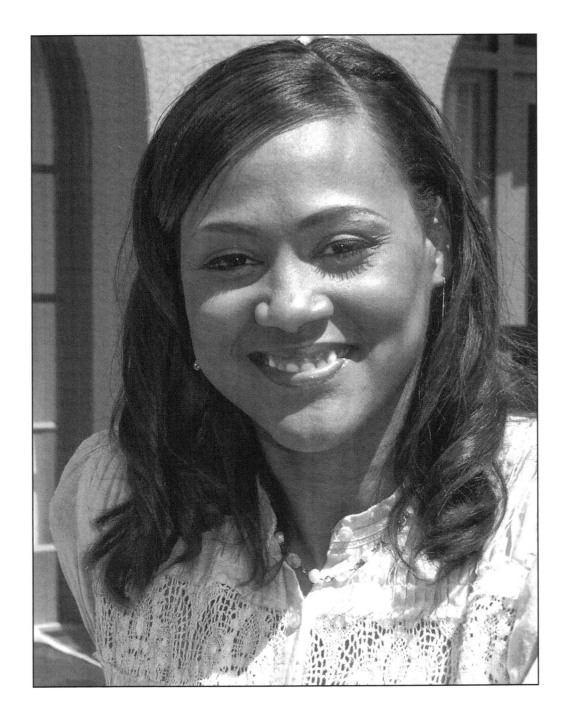

melanie mcfarland

journalist
seattle, wa

"i fell in love with myself after i turned 35. i was always trying to please other people–always willing to be the scapegoat. after years of this, i finally realized the only person i have to worry about loving me is me–and my husband who helped me learn how to love myself."

about this photo: *when i first met melly in the late '90s, she was a talented but insecure woman who was always looking for others to validate her talent. she doesn't need that any more. she's much more confident and soaring to even higher heights. this photo reflects the birth of that newly-found freedom to be the woman she's always wanted to be.*

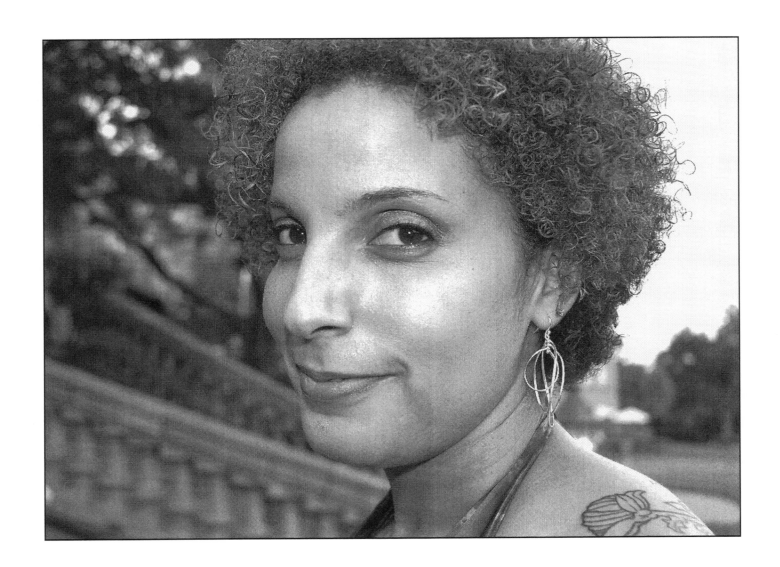

milena migani

furniture designer
rimini, italy

"i understood that i was really in love with myself when i started my new business nine years ago. it was my dream come true and every day i receive gratification for this. it makes me feel important. every day i know that i am a little better in what i'm doing. i created my dream job and this makes me wake up every morning happy to go to work. i have many people working for me and so it means also a lot of responsibility, but in the end this is the life i dreamed for myself."

About this photo: *i met milly on one of her visits to l.a. through a mutual friend. she spoke very little english but we were able to communicate fluidly, and i thought she'd be a nice addition to the book since i was trying to make it as diverse as possible. i captured her bubbly personality one afternoon in 2010 after lunch at the grove.*

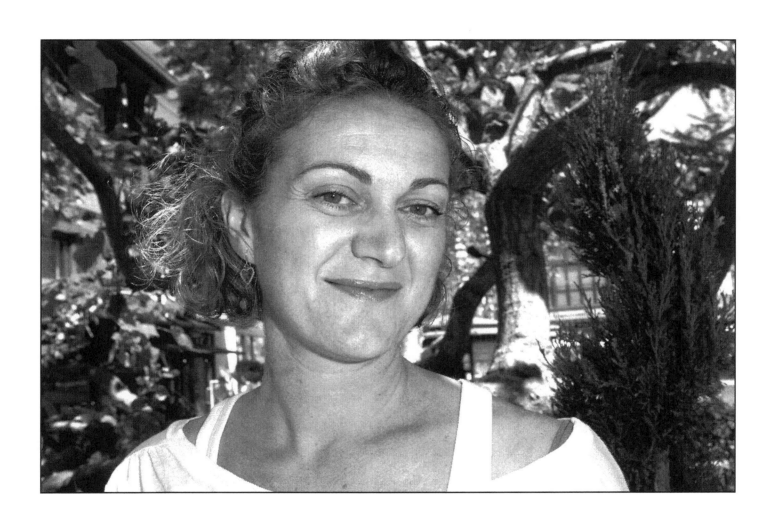

miss rosa

deceased
cincinnati, oh

"everyone around me was so filled with hate—the nazis—and that was so stupid to me. i didn't understand the hate. It didn't feel good. so, even though people hated me for no reason i learned early on to love myself. it was the only way to make it through all the insanity."

about this photo: *i formed a special bond with this german-born alzheimer's patient at my dad's nursing home in 2008. every time i'd go back to cincinnati to visit him i would pray that she was still around. this shot was taken in the activity room just before my dad passed away. it was during one of her more lucid moments that i asked her the question. we talked at length about what it was like to be in germany during the war. i only saw her one more time after dad died. i found out she passed away the following year when i went to visit her.*

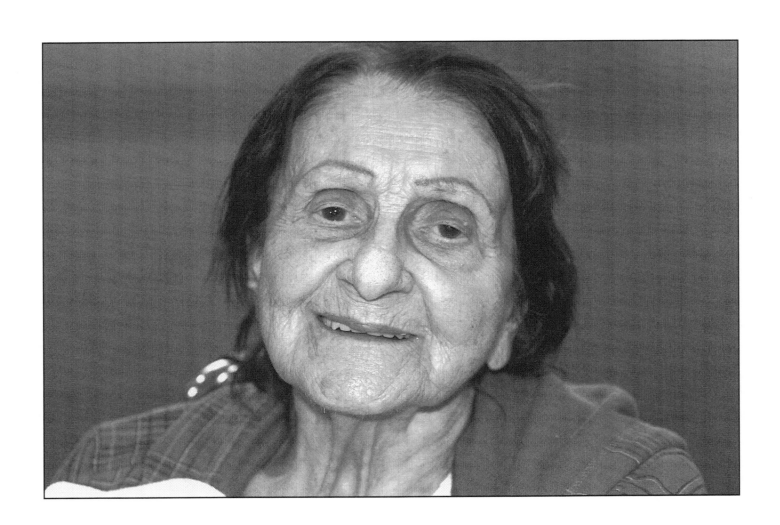

mo'nique

oscar-winning actress/comedienne
atlanta, ga

"you know what? it's still happening. i'm really dealing with me. so, it's still happening. i dig the sister in the mirror looking back. i dig her. but she still has a lot of growing to do. so, it's still happening."

about this photo: i captured mo outside a luncheon in her honor at philippe chow's in west hollywood the day before she won the oscar for best supporting actress for her role as an abusive mother in "precious." everyone in town knew she was going to win, but i loved the fact that she wasn't all wrapped up in her own hype. on this day she was more thrilled about meeting ruby dee.

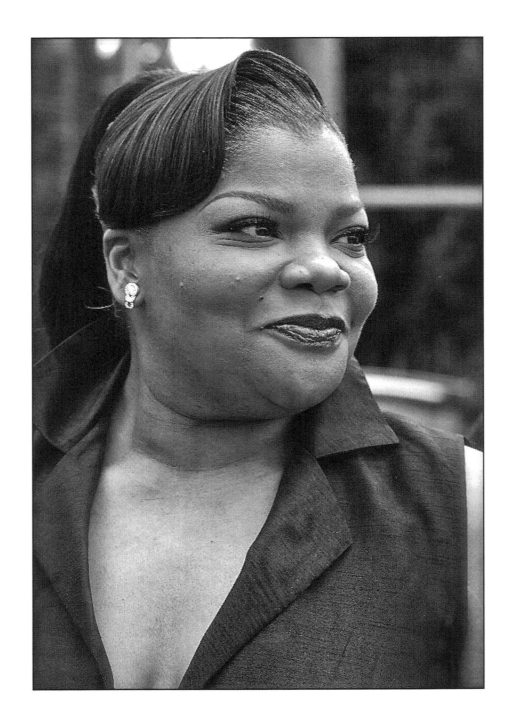

molly faulkner

real estate agent
monterey park, ca

"i learned to love myself when i was 15 because my childhood had been difficult. it had been four years since we escaped the genocide from khmer rouge (cambodia) and come to the u.s. i was a depressed child because i didn't have a mom and couldn't speak english well and just wasn't fitting in. plus, i was questioning myself as to why i was alive and so many others weren't. when i was 15 my father told me to move forward and assimilate myself to the american culture. once i did that, a good life started. we used to call america heaven. being here helped me love myself."

about this photo: *i've known molly for years but hadn't seen her since i started this book. one night as i was looking at photos i felt the book was still lacking the diversity i wanted. i remembered that she had a fascinating back story so i rang her. we met for lunch in l.a.'s chinatown and took these photos at a plaza nearby in 2012. molly was really nervous in front of the camera and had this frozen smile or frown. this is one shot in which she loosened up a little.*

journey to the woman i've come to love

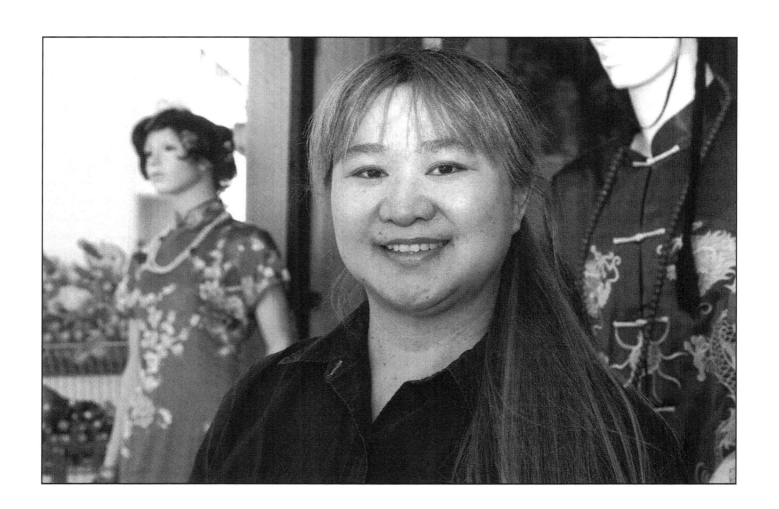

monique ollier

journalist/professor
paris, france

"i must have been about 30 and i was living alone after being married for about 10 years. i think for the second time in my life – i think the first time was about 5 or 6 – i realized i was going to die one day. from then on, every minute would be important. it would be important for myself and i had to be true to myself. i cried, cried, cried and then everything was much clearer. and, i decided i would never try to find my own truth in other people's eyes but only in mine."

about this photo: *i'm an extreme sentimentalist, which is why i still keep in touch with friends i made in kindergarten. monique was the afs french exchange student in my high school. we weren't exactly friends but i remember thinking how much more mature she was than the rest of us. i literally hadn't seen her since 1976. in the spring of 2012 when i arrived in paris i googled her and voila. after a long conversation about our lives and how similar they were, i asked her to be in the book. this shot was taken right outside the pantheon. she was on her way to the sorbonne where she teaches.*

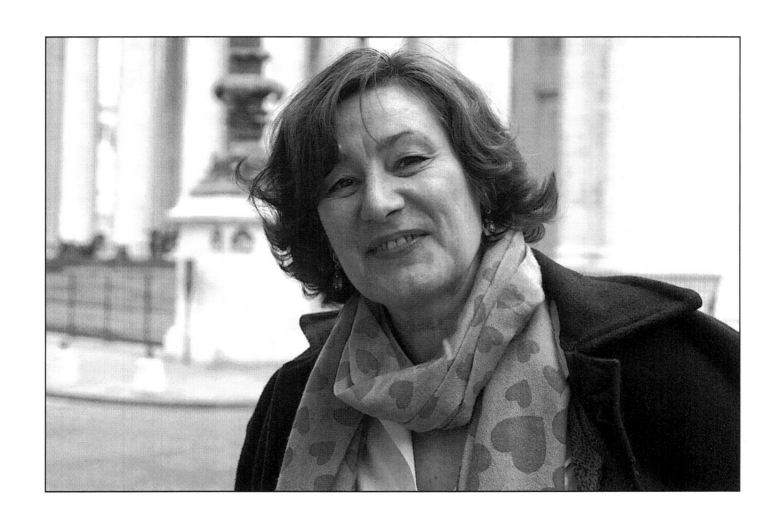

myrlie evers-williams

civil rights icon/author/teacher
lorman, ms

"that's a difficult question. i was always a very, very shy person. medgar (evers) would ask me to speak up, to be upfront, and do this or that and i would always say, 'no, no, no.' the night of the day that he was assassinated i wanted to go to a mass rally and people said, 'no, that you're too distraught. you cannot do that.' i said i want to go and they said, 'we will not take you.' i remember standing and saying, 'i will walk.' i think that was kind of the turning point for me. it wasn't that i have not had, over a period of time, some questions about my strength. but i know i'm strong. i know i'm a fighter. i hope i have done some good and will do more. but i will take on anything and anyone that tampers with my life and my children. and, with my husband's memory, my country—my people, for that matter. so, get in line. i can hold it all."

about this photo: *it's very surreal to be in the presence of such a strong woman. she is among my most favorite people to interview. i had to grab this shot quickly because everyone in the room wanted to get next to her. ironically, it was taken at the museum of tolerance in l.a. in early 2012. it's ironic because i can't think of any woman—other than mrs. king or betty shabazz—who had to tolerate so much to get past the absurdities that disrupted her contentment.*

journey to the woman i've come to love

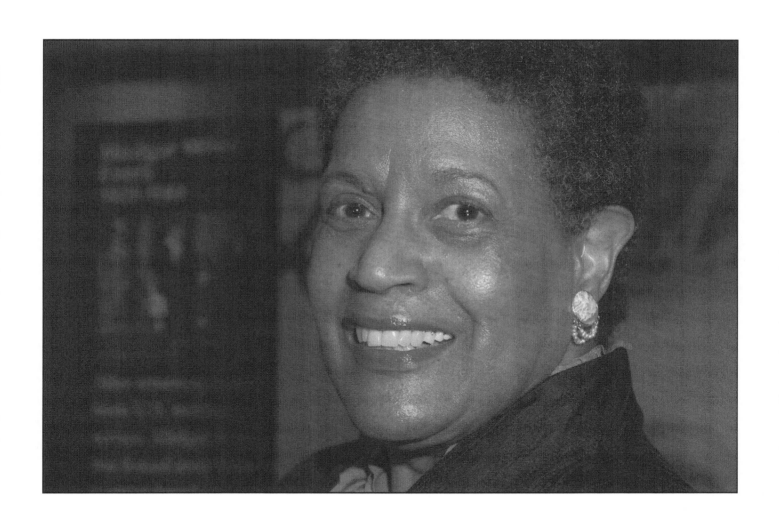

naomi judd

grammy-winning singer
franklin, tn

"i think our personal ground zeroes really shape us, define us and give meaning to our everyday lives. the first major life lesson that comes to mind was when i was living out here (california). i was on welfare, i didn't have a car. i fell in lust with the boy next door who happened to be an ex-convict. i knew nothing about this. one night he broke in and raped me and beat me and then passed out from a heroin overdose. i escaped with my two babies and we went to the holloway hotel in santa monica and the clerk let us have a room because i was so battered. that night i realized that my battered face looking back at me in the mirror was a metaphor for my life. i didn't recognize myself. so, i decided to start getting rid of everything that wasn't working, i moved back to kentucky and put myself through nursing school. i earned more than a degree. i earned self respect."

about this photo: *naomi and i had one of the greatest lunch meetings i've ever had in my life. it was back around the turn of the century at the ivy in beverly hills. loved her. anyway, when i started this book she was one of the first people i went to afterward but couldn't get past her gatekeepers. in the summer of 2012 i ran into her at a hotel and had yet another one-shot opportunity. thank you god.*

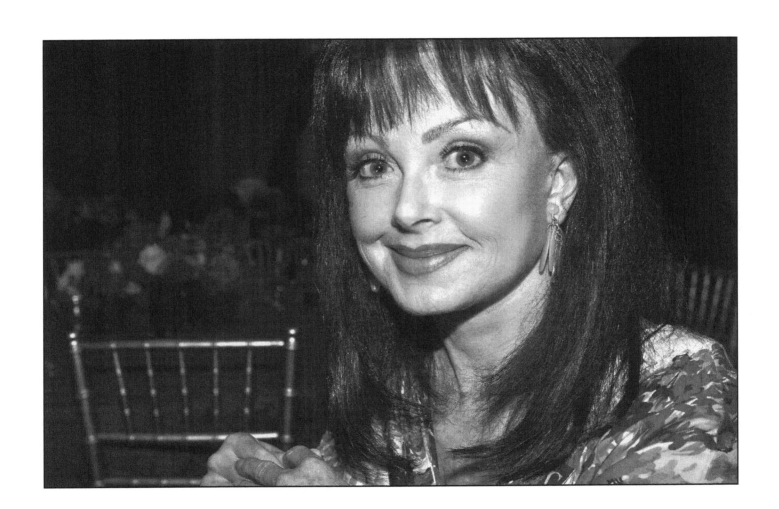

at what point did you fall in love with yourself?

nichelle nichols

actress/filmmaker
los angeles

"i fell in love with myself when i was a baby because my father told me i was the most beautiful little black thing he had ever seen. my father was half black and half welsh and i believed him because he was married to my black mother. i believed him because i never had any reason not to believe him because he never lied to me."

about this photo: *i was interviewing ms. nichols for a tv special she was about to appear in that featured popular characters from iconic tv shows. she, of course, was uhura in the original "star trek." i loved the fact that she looked about 30 years younger than what she is, was rocking the natural hair and had insights into the business and life that i had never heard before. i captured her in 2010 as she was talking to mike connors from "mannix." it was much better than the shots she posed for.*

journey to the woman i've come to love

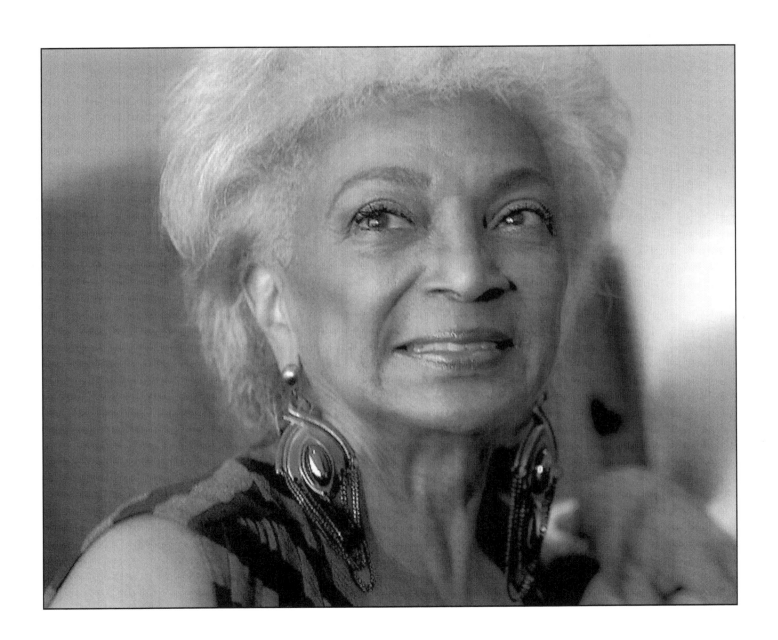

nicole ari parker

actress
los angeles, ca

"wow. i think i fell in love with myself when i fell in love with god. when i knew for sure—like oprah says 'what do you know for sure'—when i knew for sure that there was one, that there is one and that there always will be one—and that he is inside of all of us. i let all of these insecurities go, i let all this nonsense and these misguided conceptions of what is beautiful go and what is sexy and what is powerful and what is successful. when i felt that light inside of me—and i'm not trying to be esoteric—when i felt that light and power inside of me—i felt unstoppable. i felt empowered."

about this photo: *i have always been mesmerized by nic's eyes. and i've always known that she's smart. that combination of intelligence and good looks is always a blessing. i caught up with nic one night in 2010 at a party in her honor. the light was horrible and my flash wasn't working. i dig the grain in this shot though. it reveals her enlightening spirit and wondrous tapestry.*

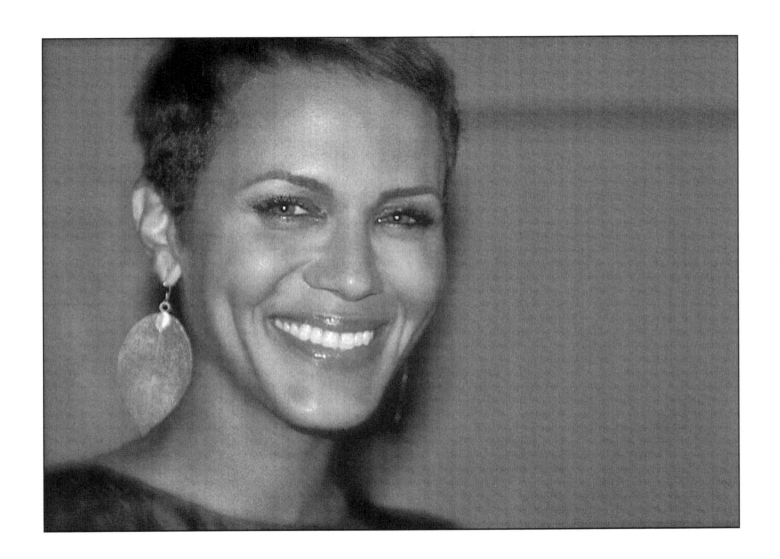

nikki giovanni

poet/professor/activist
christiansburg, va

"i've always enjoyed me. but i guess you could say i really fell in love with myself when i realized i was smart."

about this photo: i've known nikki since i was a child. she is my literary she-ro. every summer nikki comes back to cincinnati to attend the atp/wta tennis tournament in mason, oh. and stays with my brother and sister-in-law. she happily agreed to pose for this shot on the enclosed patio of my brother's home."

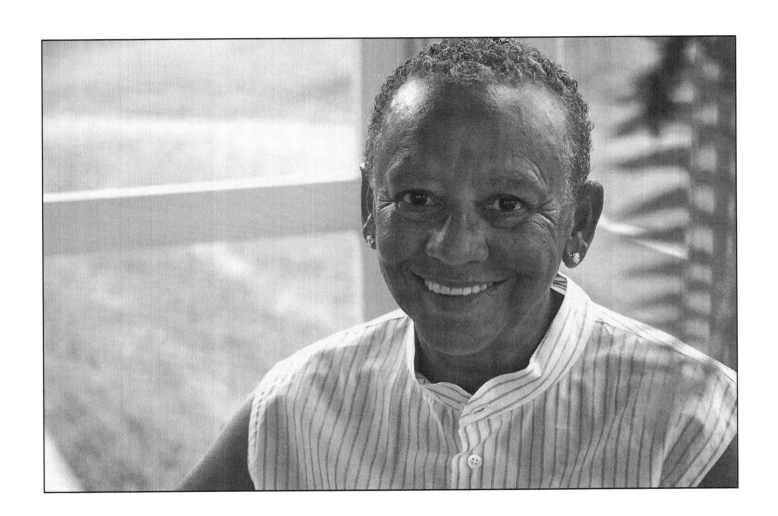

nnasarawa prempeh

retired engineer
los angeles, ca

"ooh, from a small child…my father told me that there was nothing better—it was me and god. ever since then it's just been god and me. he does his part and i do mine. we love each other."

about this photo: *in 2010 i was walking around a street fair in leimert park and stumbled upon an older woman sitting in a booth with this incredible hat on. i asked if i could take her picture because it was just too good to pass up. when i looked at it in the viewfinder i knew i had to add her. it wasn't until july 2012, however, when i decided she had to be the cover. to me, its' one of the most powerful shots in the book. this is a strong, determined and smart woman who loved herself in the womb.*

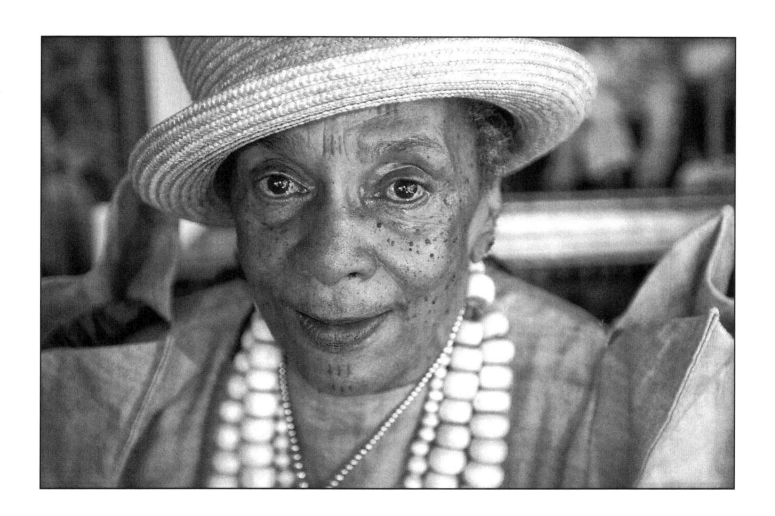

oum el ghait

singer
casablanca, morocco

"i fall in love with myself every time i discover a new facet of this woman i am. in the beautiful days when my strength makes my enjoyment, and in the difficult moments when my vulnerability sharpens my faith. i am in love with this mystery that i carry in me, in the love of my ancestors whom express themselves through my voice and in these little gifts in the shape of my fingers. and, because life is a miracle, i like knowing that it is in me."

about this photo: *at the time this photo was taken in 2010, oum was too young to make the age criteria for the book. but after listening to her talk over a traditional moroccan dinner, i knew she possessed the wisdom of the ancestors and decided to make an exception. here she is looking all mysterious and wise at a hotel in rabat.*

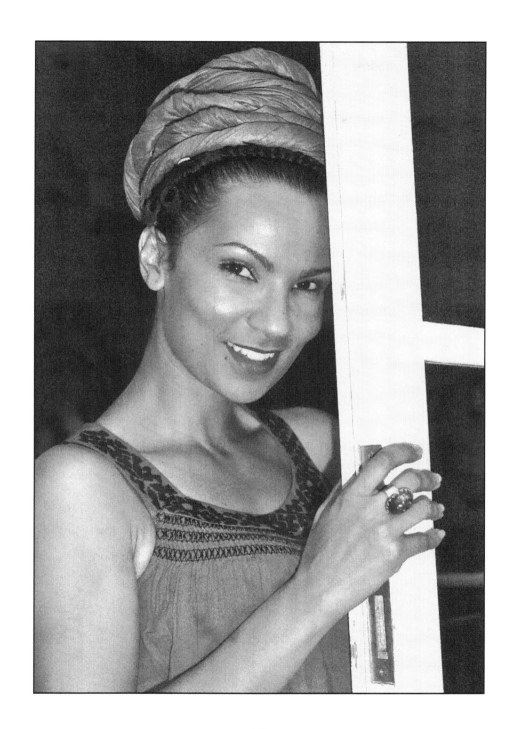

perle meneses nunez

ceo
irvine, ca

"raising my boys and starting a business was so consuming that i was entirely focused on servicing others for many years. during that period i didn't take the time to explore personal interests or to "love" myself, but it led me down the path of finding myself. and, prior to having children i was too young to have that type of awareness. it is the concept of loving who i am that has evolved over different phases of my life. i reached what i feel was a more mature love at age 40, when i became more accepting of my perceived shortcomings and extremely grateful for my blessings. although i still carry what i view as a healthy dose of self-doubt, i have now reached a phase where i can freely celebrate my life and relish in the results of a lifetime of work, education, and effort."

about this photo: *i met perle in south Africa when she and her husband cirilo were celebrating their 25th anniversary. i initially shot her in the bush and loved that photo because it seemed so soulful to me. it wasn't at all glamorous and that really appealed to me. last year, however, she asked for a re-shoot and i shot her on the roof of a downtown l.a. loft building.*

journey to the woman i've come to love

queen latifah

oscar-nominated actress/musician/filmmaker/author
los angeles, ca

"at 18, i was already working at being cool with who i was, but at 24 something just hit me. i started to really look like my mom. maybe it's when i first started to see my mom in me and that made me feel really good about myself. that's what made me love me."

about this photo: *dana (queen's real name) is one of the few celebs who seem to recognize me every time we meet. even when she doesn't she still speaks. we were hanging out in the green room at a BET event in 2009 when i approached her about the book. i only got one frame off before she bolted. not too bad.*

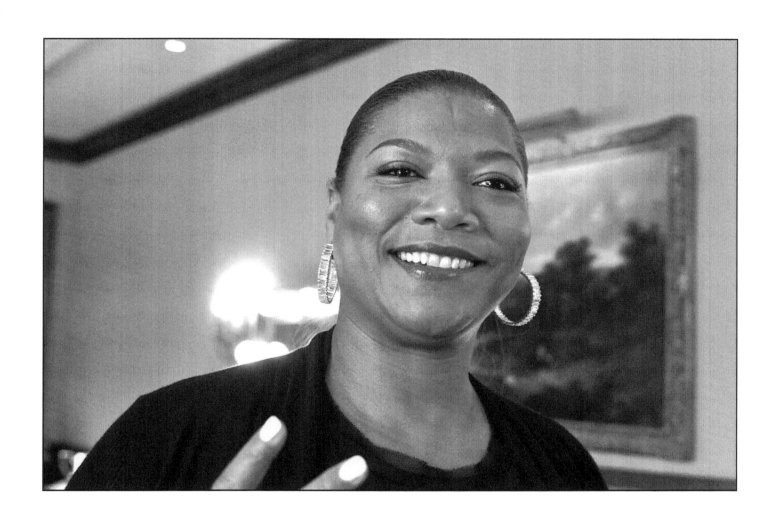

rachel robinson

singer/songwriter/actress/teacher
portland, ore

"i learned to love myself under a mosquito net in the high jungle of peru. i had been lying there feeling sorry for myself because it seemed that all my great love was wasted on people who never change. i had what i can only call a mystical experience, where i channeled the wisdom that if i withdrew all my seemingly futile projections of love aimed at others, and turned them around to pour into my own heart, then the entire landscape of my life and my community would instantly shift. i sang to myself and felt a warm light surge into my chest. i felt full and bright and whole and loved.

when i returned to the states, all my relationships were indeed shifted. my love was being received, love was being shared, and i attribute that to simply loving my own sweet self."

about this photo: *rachel is a friend of a friend and i captured this shot at the home of our mutual friend three years ago. i don't know her well but everyone who does says this is classic rach.*

journey to the woman i've come to love

robbie montgomery

reality tv star/restaurant owner/former ikette
st. louis, mo

"from the day i was born. i knew i had it, i knew i would like to be in love. so, i couldn't find a better person than me to love."

about this photo: *i was in st. louis visiting the sweetie pie's set when i asked miss robbie to be a part of this book. she didn't hesitate when i asked her the question, which was rare. i took this shot of her in her new restaurant while it was still under construction in 2012.*

robin roberts

co-host, good morning america
new york, ny

"oh my goodness, when i was diagnosed with breast cancer and i went on the air bald. i was one of those sisters, like 'oh my hair!' i'd go swimming and i'd do a dog paddle because i didn't want my hair to get wet. once i went through cancer and i held my head up high on national television just as bald as you can be, that's when i fell in love with the woman that i am."

about this photo: *this was taken at the 2009 academy awards. robin just looked stunning in a form-fitting bright orange gown. i think this not only shows her radiance, but also her gratefulness of having made it through the storm. it had been two years since her bout with breast cancer.*

journey to the woman i've come to love

rodi alexander

journalist
boonton, nj

"i don't think that i am there yet. i think i'd like to be but there are so many different things about myself that i don't like. but the thing that i do love about myself is that i raised three kids by myself—raised them without any help from anybody after having two husbands who died. that's what i love about myself. if i die, i don't have to worry that they're going to hurt anybody. they're good people."

about this photo: *rodi is such a character. i've known her since 1997 and there have been times that i've tried to avoid her because she can be a bit much sometimes. but as she's grown older, we've grown closer and i began to notice how expressive her face was and wanted to capture it. i think i did in this 2009 photo.*

roma downey

actress
los angeles, ca

"i was probably in my '40s, i should think. i really moved into much more of an acceptance of who i am. i feel like much of my past i spent looking back – a little bit with longing, because i'm an immigrant daughter – or looking forward in anticipation.

now i feel like i've finally caught up with myself and i am here and happy to be here."

about this photo: *i ran into roma on a night in 2011 when it was all about her husband mark burnett. she'd been off the scene for quite a bit and it occurred to me that she might have done some growing during that time. i caught her during a moment when it was just about my camera and her.*

roma mafia

actress
los angeles, ca

"that's an interesting question…i think it's like anything—ebb and flow. some moments i do and some moments i go 'what the heck am i thinking?' i think the more i look at my mom, the more i look at the beautiful women in my family, the more i see myself reflected in them. it is sort of like this mirror thing. we all get to bounce off one another and i get to see my womanness in them."

about this photo: *i ran into roma on the raleigh studios lot one day in 2011. she was guest starring on an nbc show and this shot was taken just after she had emerged from her trailer.*

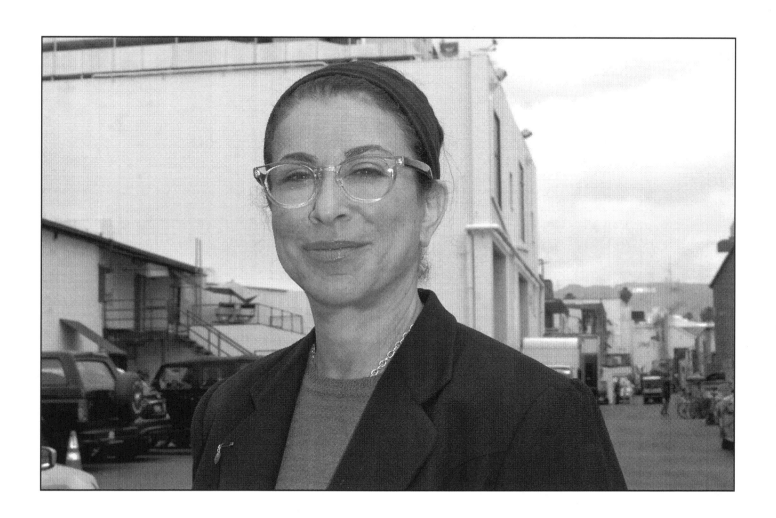

ruth kuzub

shop owner
new york, ny

"i can't answer that. i think it's one long, never-ending process throughout life."

about this photo: as was the case with alystyre julian, i was caught without my proper equipment one day when i was exploring my old haunts in the west village in the spring of 2012. i knew immediately that the old lady sitting in the little shop with her two cats was a character. ruth sells silver and i needed to replace a chain that had broken. while i was waiting one of her cats jumped into her lap. i tried to catch that but just missed it because i was working with a slow compact camera. the ensuing frame was just as delicious though!

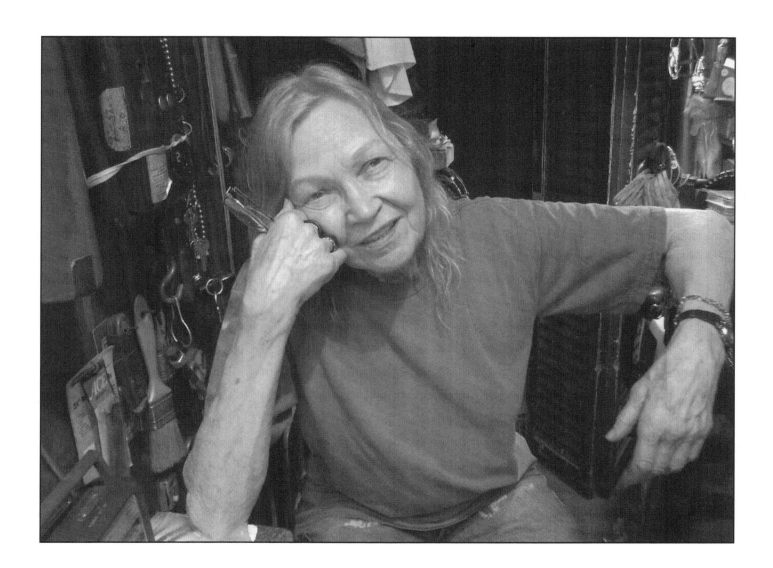

sacheen littlefeather

activist/comedienne/actress
san rafael, ca

"i found out i had a good sense of humor, i learned how to laugh at myself. i was young, which was a long time ago because i'm having senior moments! indian people do have a great sense of humor. unfortunately, the dominant society doesn't realize that but we've been laughing at them for a long time! a person of color has to learn to laugh at the ugly as well as the beautiful. if we didn't, we would not survive."

about this photo: *like most people, my first memory of sacheen was when she appeared at the academy awards to reject marlon brando's oscar for the godfather in 1973. well, 37 years later i ran into her in the lobby of the beverly hilton hotel and she just cracked me up. didn't get great shots of her but man, she was something else and i loved her answer to the question.*

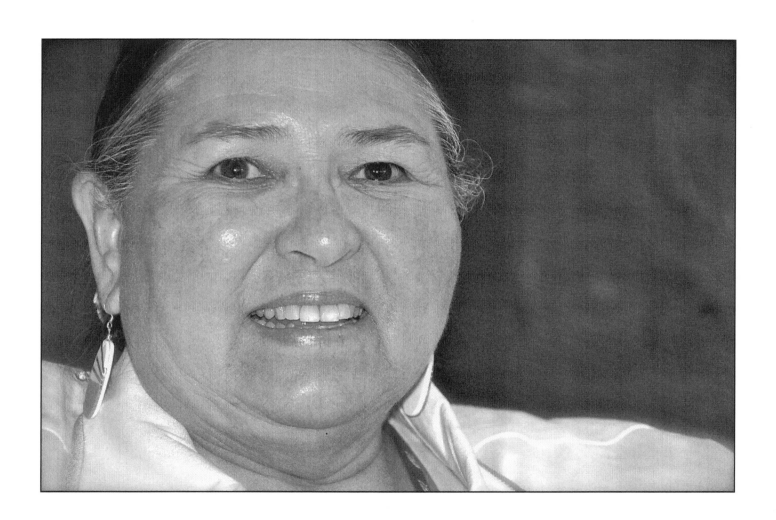

sanaa lathan

actress
los angeles, ca

"my moment was probably a more thought-out conscious thing about falling in love with myself. my mother was always a spiritual seeker in that she tried many different religions. so, as a child i was exposed to that. when i got into my '20s, i gradually started to seek my own spirituality. if you choose to look at things that are good, then good things will come. if you choose to look at bad things, bad things will come. i tried to cultivate that early in life and it helped me love myself. your perspective paves the road that you walk. it's something you have to work on every day as a woman."

about this photo: *sanaa and i were both leaving for london on the same day in 2009. she was going to do "cat on a hot tin roof" on stage and i was going to a film junket. she invited me up to her home in the hollywood hills while she was packing it up for a six-month run. she opened the door wearing a wife beater and some shorts. she pulled that wrap out of the closet and suddenly she looked like someone on the cover of vogue!*

journey to the woman i've come to love

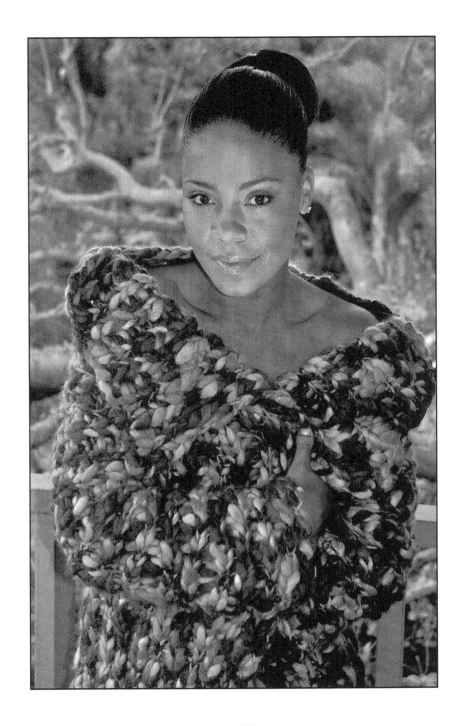

sandra lind

retired
venice, ca

"i knew it as soon as i was born! it's as simple as that."

about this photo: *sandy is such a character. although she's a little hard of hearing, she has this innate ability to see what you're saying by just looking into your eyes. there's nothing cooler than spending a lazy afternoon in venice with sandy. i took this photo as she was entertaining some visiting family members.*

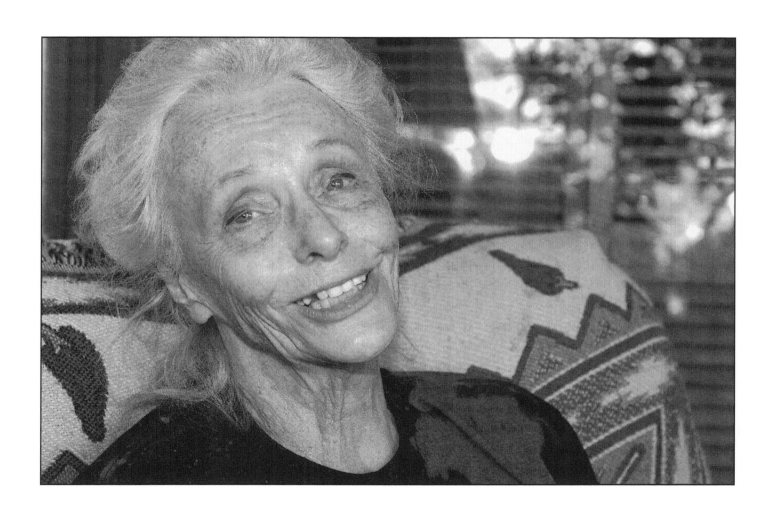

sara griffith adducci

spiritual director
la grange, il

"i was a strong young woman raised by many generations of strong women including my mom, whom i admire greatly. being in a long-term abusive relationship corroded my confidence, soul and any sense of having a voice although i did not realize this when i was trapped in it. i kept thinking that since i was a strong woman, my sense of loving myself was not being affected by this one part of my life. i was very wrong. it slowly ate away my whole sense of self and it rained on the rest of my accomplishments. i was lost. now, i have an unshakeable presence of acceptance of who i am after deciding to stand up and chose love of myself as a human. i respect myself and my decisions. getting to this point has been an incredible learning experience for which i am grateful to my noble friend, the ex. i was no heroine. i did this at the time as a means of survival but it almost has become the greatest gift of grace because in the end i had to chose myself and what i knew to be true in my bones. it was a rough passage that brought me back to the place where i had begun. i am now loving myself as a human being and a woman. perhaps the world doesn't see me as strong, but to me, i am sara, full of grace."

about this photo: *sara was absolutely the last add to the book. she submitted this testimonial to the journey facebook page and there was no way i couldn't include it. fortunately, i had a picture of her that i'd taken at our high school reunion in 2006. it's a shot of her dancing and it so appropriate with this quote. girlfriend has learned to dance again. that's love.*

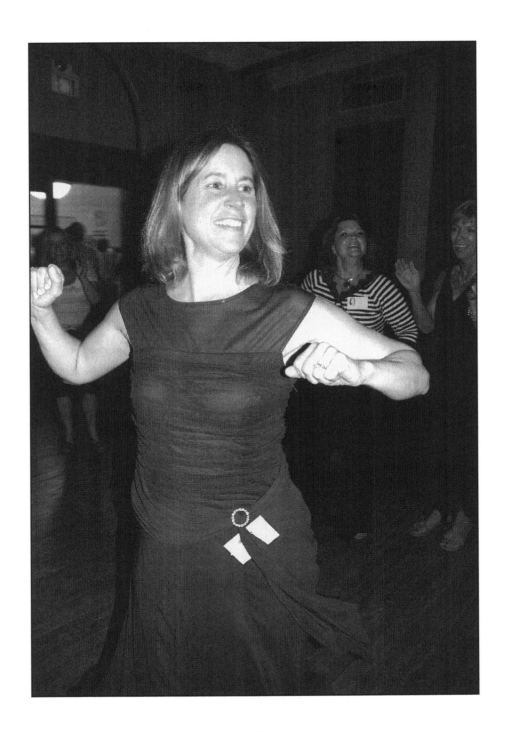

sharon gless

actress
los angeles, ca

"i think i've loved myself as a human being for a very long time. but then i can get discouraged because i am vulnerable to outside comments. i never seem to stay the same. my weight goes up and down, as do the sizes of my roles. i probably sound shallow but i've evolved through all that. there are some good days when my eyes let me see absolute beauty. i'm 67 and I love being this age. i'm very proud of living and succeeding and having friends and family who love me. so, journey to the woman i've come to love? i do love me."

about this photo: *ran into sharon at a party in beverly hills in 2010. she just seemed fascinating and i loved the way she looked. short silver hair, big black glasses. i also appreciated her unfiltered response to the question. it was a win-win.*

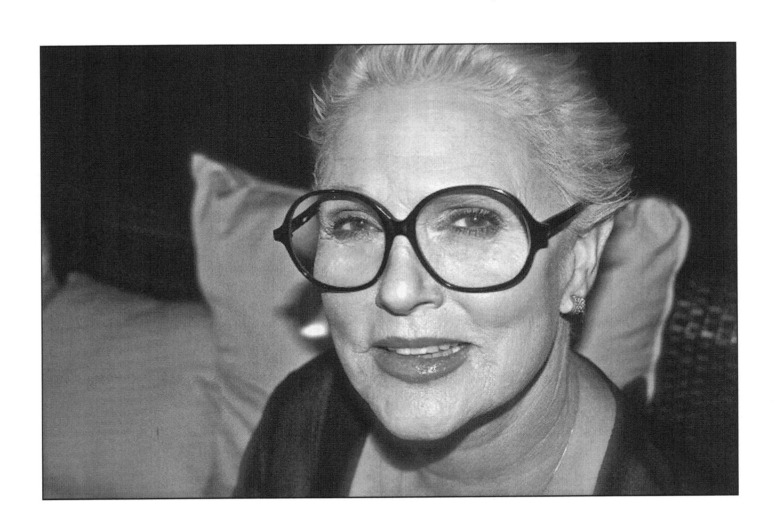

sonia sanchez

poet/professor/activist
new york, ny

"i think at some point i really fell in love with myself and began to understand the need to love one's self was when i listened to the words of people around me. when i got up on a stage and read a poem, i heard people say 'yes, sister, you're right. keep on teaching that.' i began to love myself most effectively when i began to do work in the civil rights movement when i was in new york and i saw people respond and saw how we began to change people. i did like james brown said: 'i guess i better kiss myself.' so i began to kiss myself and all the other people who were in the struggle."

about this photo: *taken in 2012 at the freedom sisters exhibit in l.a. ms. sanchez personifies cool.*

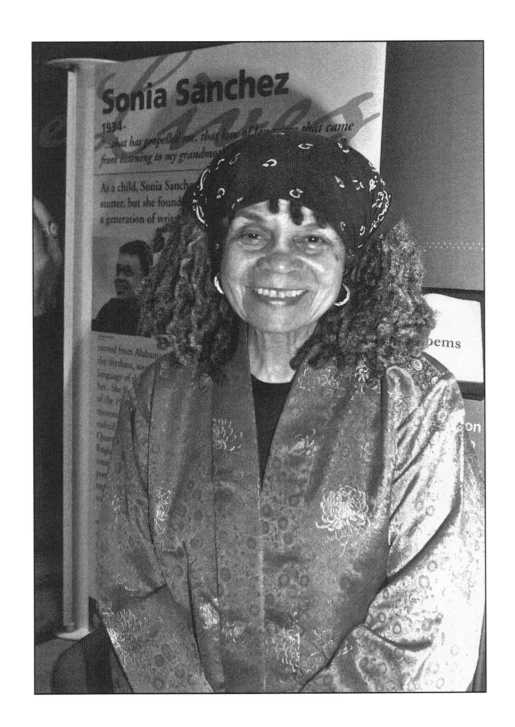

susan sullivan

actress
los angeles, ca

"i think this is the way love is: you fall in and out of love a lot. sometimes it's with different people and certainly it's with yourself. there are times when i am charmed by myself…delighted by myself. other times i'm deeply angry. i had a problem with my mother during one period and i really couldn't connect with her. it was very, very hard for me to be comfortable within my own skin. i think if a woman, or a man for that matter, doesn't have a good healthy relationship with their mother, or doesn't work through the dynamics, it's very hard to love yourself. but that core love, which is based on your sense of values, your self-esteem and your sense of 'i can mature' without having to rip my face apart every 20 minutes, that love is deep and grounded and full."

about this photo: *susan, like dana delany, was quick to say "yes" when i approached her about the book in 2010. she thought it was a marvelous idea. i only shot two frames of her. in one, she's looking into the camera, and then there's this one, which i thought was more expressive and intriguing.*

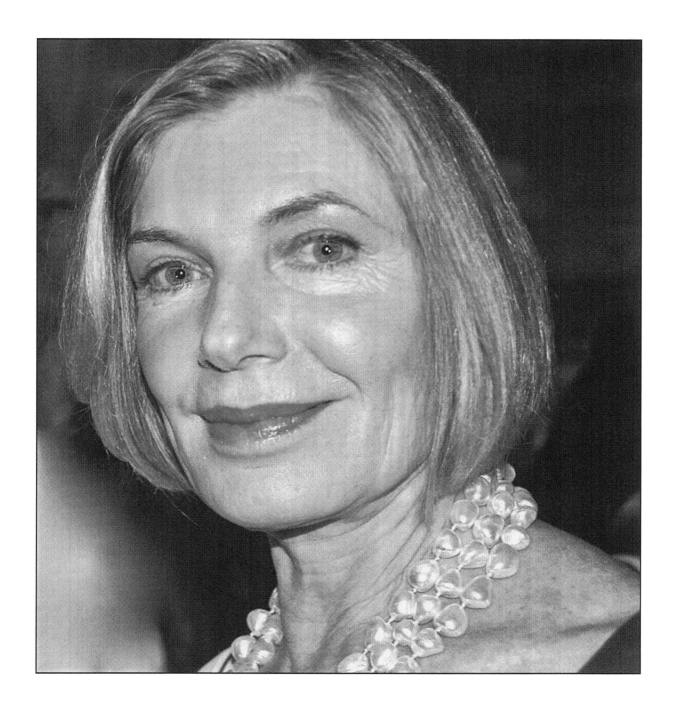

suzanne malveaux

cnn anchor
atlanta, ga

"professionally i had hit a glass ceiling. i felt like there was more i could do, more i aspired to do. i was looking for something to help direct me or guide me. a friend suggested that I do a triathlon….i started my lake swim and panicked because seaweed around my leg was pulling me down. i started swallowing water – i had to talk myself out of panicking. i was almost across the lake when i saw this guy shouting through a bullhorn: 'are you ok, are you ok?' i looked behind me and realized i was the last person in the lake! at the finish line, people started cheering. i got this surge of 'rocky' in me. i was so excited. i really felt great. i was dead last. but i felt the next best thing to being in first place was being in last place. what i took away was that it really is about the process. it gave me strength and confidence not to give up but to keep moving forward."

about this photo: *i shot a series of exterior and interior photos with suzanne at her home in silver spring, md. we'd met years before, but she was really nervous for about the first 30 minutes. once we moved in the house she started to relax. i chose this shot because she's always so serious on tv. she has these incredible eyes and i wanted to show her softer side. and, she has definitely moved forward since then.*

journey to the woman i've come to love

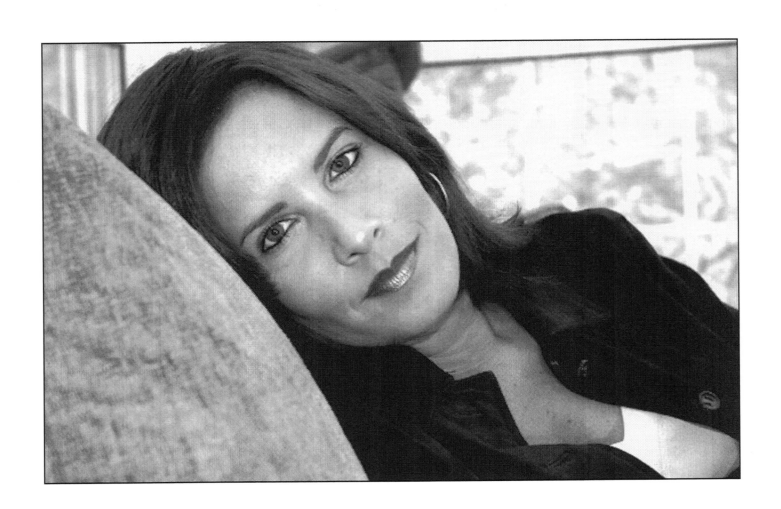

synthia saint james

artist
los feliz, ca

"i would say a particular time stands out because it's the most recent. it was about seven years ago when i decided to start gifting myself. what i gifted myself with was every morning at dawn i would go walk on the beach and say my affirmations and prayers. i decided it's good to gift other people but you also need to gift yourself."

about this photo: *this was actually another happy accident. i was so unpleased with this series of photos taken at a downtown l.a. restaurant in 2009, but got lucky with the one in which the flash didn't go off. i like her emerging from the dark to embrace her light.*

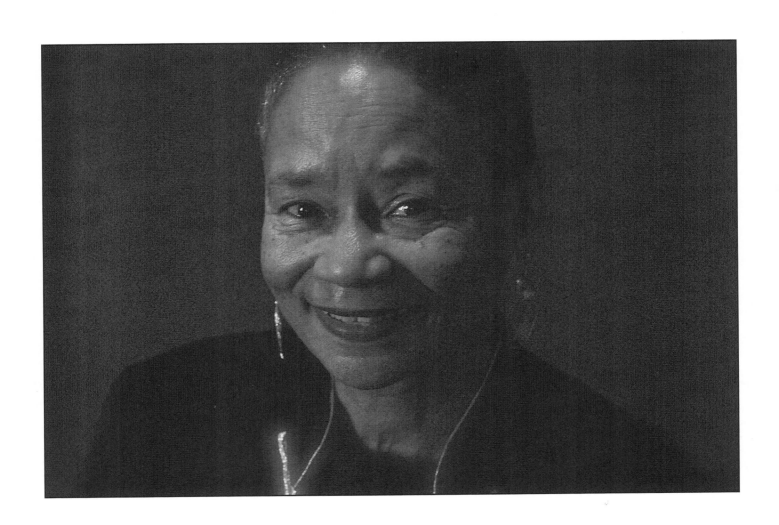

tananarive due

author/screenwriter/professor
stone mountain, ga

"to fall in love with myself has been a long struggle. i would say it started to happen in my late '20s. i started to take control of my life. i walked away from negative influences and worked on myself. i got in shape and started rollerblading up and down south beach (miami). i was like 'you know what? i like hanging with me.' that was the point where i decided if I don't meet 'him,' it's all right. if i had to do this by myself i could because i'm going to be all right.' then, i met my husband."

about this photo: *tan and i met up after one of her book signings at eso won (book store) in leimert park in 2009. i hated all of those shots. we met up again at the same spot and i took this photo while we were having lunch.*

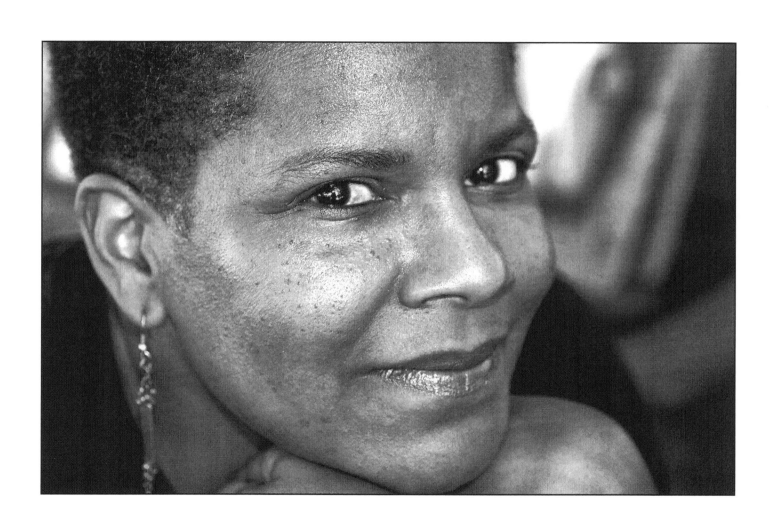

temple grandin

professor/author/consultant/expert
fort collins, co

"when i learned how to calm down and think things out."

about this photo: after having had several phone conversations with dr. grandin i got up at the crack of dawn to attend a lecture she was giving in pasadena. although she didn't appear to remember we had set this up, she posed for several photos. they were just horrid. so, i stalked her for a while and snapped this one just as she was looking up. this is pretty much the expression she had on her face all day. maybe she's not a morning person either!

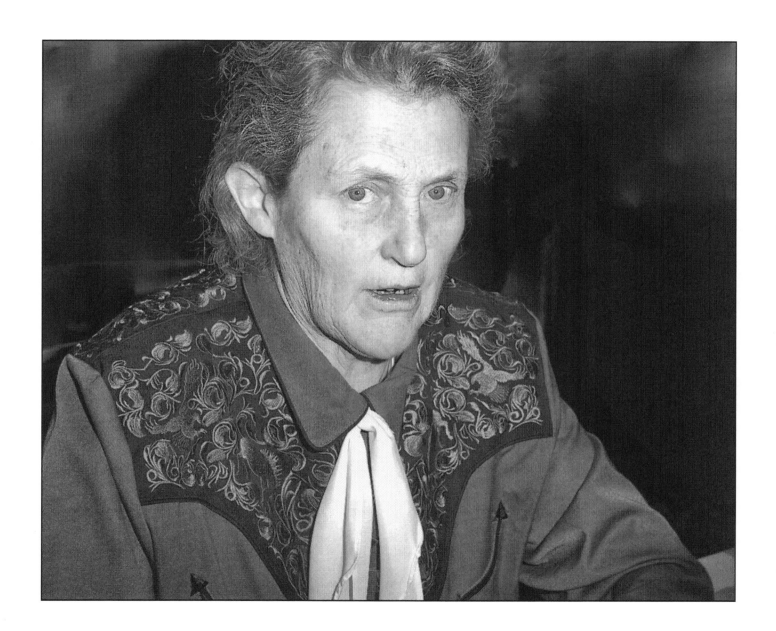

terry mcmillan

author/screenwriter
danville, ca

"i would say to some extent when i became a mother i was 32. what i had done was a miracle that i didn't think was possible. and then raising my son did wonders for me as a human being and as a woman."

about this photo: *this was taken at the 2010 image awards. both terry and i wanted to do a re-shoot but our schedules just never did jibe. i still think she looks good in this one!*

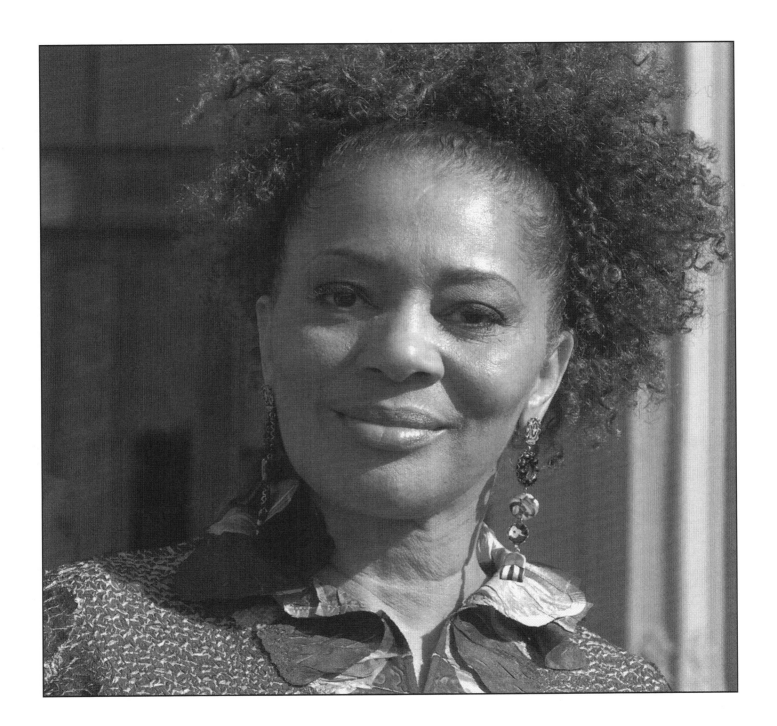

tina andrews

producer/ author/director/artist
new york, ny/malibu, ca

"my father always said that if you don't love yourself you're not going to be able to love anyone else. but the age when i really started to say that i know who i am and these are the things i'm going to accept from people or not accept from people, which dovetails into whether you love yourself, would probably be about age 30. i was still an actress, which means that you're always trying to be something else for other people. you don't necessarily know who you are unto yourself. i felt that i was too old to be playing the kids i was playing and i made a conscious decision to have the kind of career that i wanted for me. not necessarily for hollywood, not for america, not for my family. that's when i started to love me and accept me for who i was… all five feet of me, all nappy-haired me, all brown-skin, flat-foot, big-butt me."

about this photo: i've always admired this woman. i caught up with her in santa monica in 2009 when she was in rehearsals for charlotte sophia, the stage play she wrote about the first black queen of england. a former actress, she was so in her element and this photo shows it.

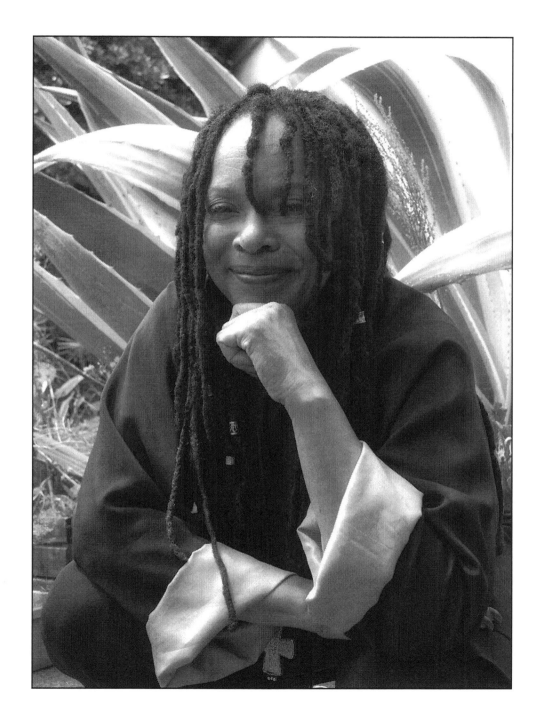

tish agoyo

ceo
los angeles, ca

"i'm starting to fall in love with myself and appreciate myself. it was a combination of self-awareness and doing what i do professionally. i work exclusively with native artists—designers–and help to create business opportunities to bring their work into mainstream america. it's really been this amazing journey for me to give them a voice. i grew up on the reservation and spent most of my life wanting to be accepted. for me, promoting native american talent has made me appreciate myself and be proud of myself."

about this photo: *tish and i were also introduced by a mutual friend. we started off our meeting with a breakfast interview at toast near west hollywood and then i shot her in the doorway of the apartment building next to mine. she just seemed so relaxed and content in this moment. i think she's actually glowing!*

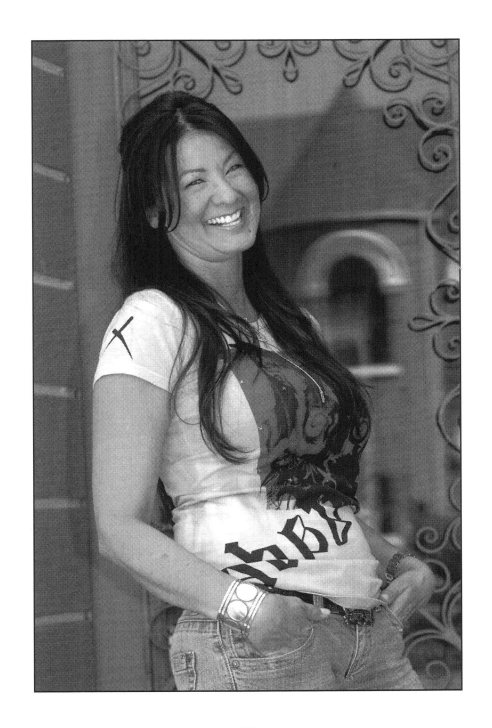

toni braxton

singer/actress
los angeles, ca

"i'm still working on myself. i have moments and i have days when i love myself. but, honestly, i'm still working on it. there's always something that you really don't like about yourself and that will make you feel insecure. i think the older you get, the wiser you get and then all of—or most of—your insecurities start to fade away."

about this photo: *toni wasn't feeling well this day. her lupus had flared up during a 2010 press conference in pasadena to promote her family's new reality show, "braxton family values." but she's a trouper and i love the way she uses her eyes. you can't really tell what she's thinking or feeling in this shot. a little mystery is always a cool thing.*

journey to the woman i've come to love

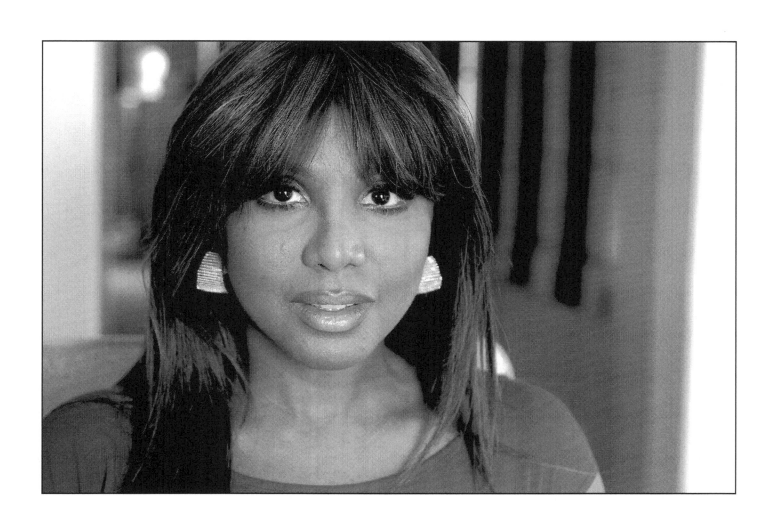

toni scott

artist
chatsworth, ca

"i fell in love with myself the minute i drew the breath of life. i believe we are born with an innate need to give and receive love. our first breath of life activates the love sense, the need to survive, to be loved and of loving oneself. i am. i live. i love."

about this photo: *toni and i actually met by accident. i was with a publicist friend and we were looking at spots to host my photo exhibition back in '09. this one location was closed but we saw this woman in there and she reluctantly let us in. toni was setting up her own exhibit! we started talking and exchanged information. i was so touched by her spirit that i recruited her for the book. it took a while—three years—to pin her down but we shot this outside her bloodlines exhibition at the california african american museum in l.a.*

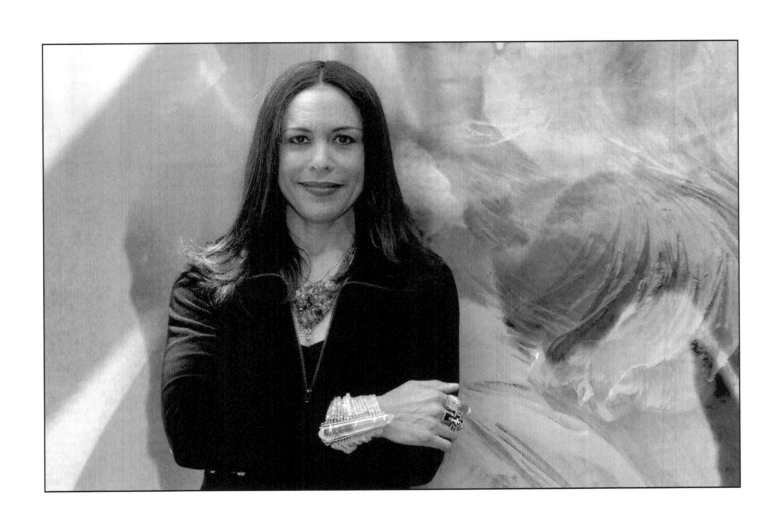

vera atchou

photographer/former model
paris, france

"when i achieved harmony between my inner and outer personality."

about this photo: *i was so nervous. i had never shot another noted photographer before and nothing was working. we were at a hotel opposite the pantheon in paris in the spring of 2012. the lighting was horrid. vera politely requested still approval and i was really embarrassed to show her what i'd shot, but she found something we both could live with. this one seemed more genuine to me than many of the others.*

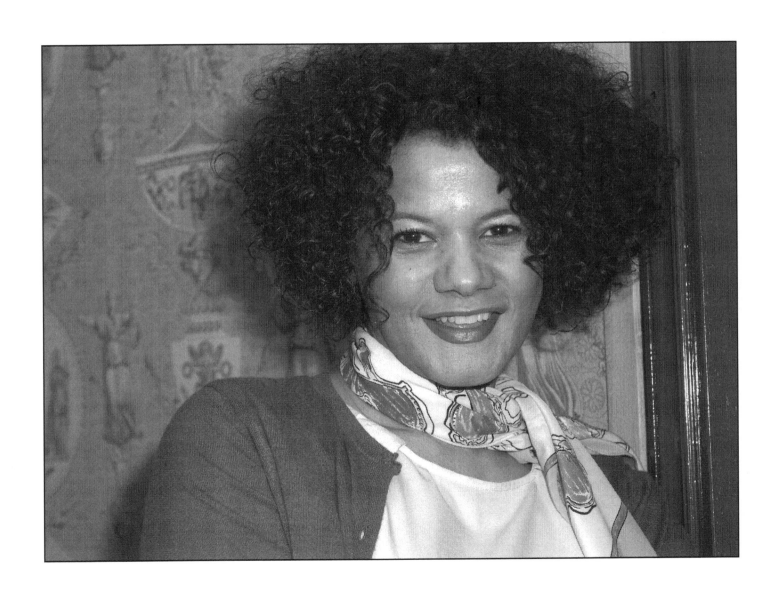

vergenia mogen

restaurant owner
curacao

"when i became 80 i recognized the fullness of my life with my children and my husband."

about this photo: *i was in a press trip to curacao during the spring of 2012 and we went to this family-owned restaurant that was supposed to be among the best on the island. the first person i saw when we arrived was this older lady sitting down with a sling around her arm. i knew instantly i had to have that face!*

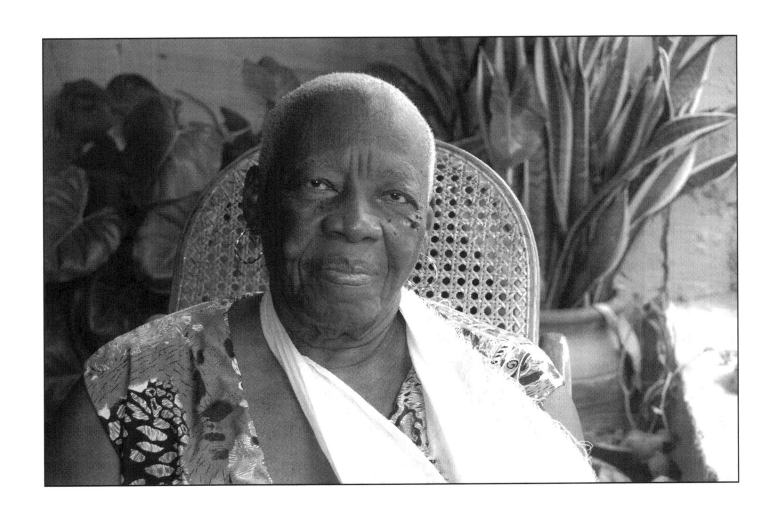

victoria haygood

intervention specialist
cincinnati, oh

"i think i fell in love with myself when i found out that my daughter was disabled and i believed that god had given her to me as a gift because she must be an angel if she can't do harm to anyone. then, i fell in love with myself when kids –the students i work with–received me the way i want to be received. when they see me in my true light they make me feel loved and then i start loving myself."

about this photo: *victoria—never vickie—was the boss of one of my bffs. she had mad spirit, a unique understanding of autisic/ special needs kids and the compassion to deal with the challenges that come with trying to help them. when i showed this picture that i took in 2009 to one of her kids, he hated it because her hair was messed up. she explained to him that it didn't matter—that she was cool with it because it was still her, flaws and all.*

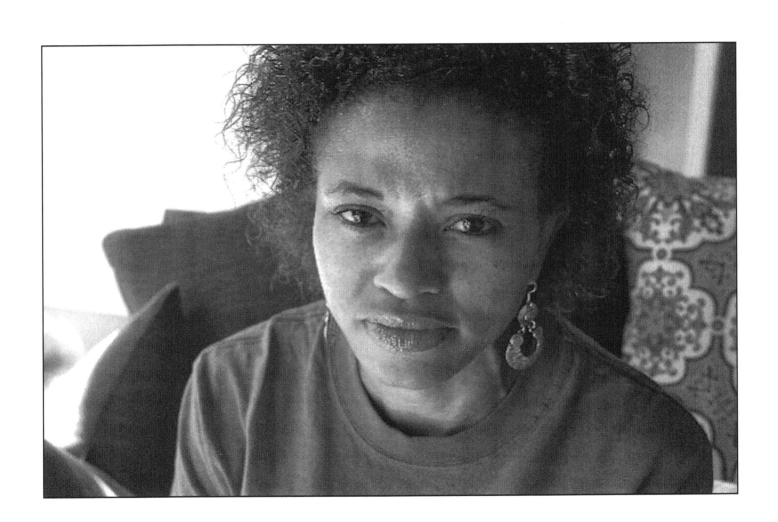

vinlyn beckles

entertainment industry
los angeles, ca

"i honestly fell in love with myself the day i graduated from kent state university with a degree in criminal justice. i looked up in the stands and saw my very small family looking down at me! in that moment i felt like i had escaped the neighborhood i grew up in and was really on my way. i left cleveland the next week and never looked back."

about this photo: *this shot was taken at a charity event in 2011. vee always has the hottest hairstyles and i love her not because she's my homegirl, but because she's always so real and makes me laugh.*

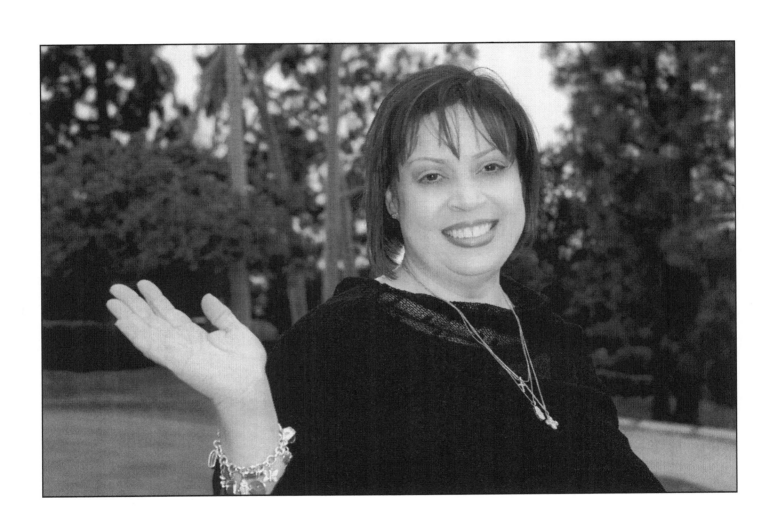

Add your own journey

add yourself to the book.
at what point did you fall in love with yourself?

acknowledgements

it didn't really take a village to pull this book together, it took a galaxy.

it took god, who put the idea on my heart years ago. it took people all over the globe telling me what a great idea it was. it took women whose low self-esteem prevented them from loving themselves. it took men, who wanted to know what was up with the women they loved. it took the few people who said no, and the hundreds that said yes. it took my mother, a woman who has perhaps never learned to love herself because her formative years were as langston hughes once wrote, "no crystal stair."

but, because i grew up watching her overcome every rock, boulder and mountain placed in her path, her struggles gave me the strength to endure adversity at a very early age. her dreams weren't deferred, it's just that no one ever told her she was allowed to have them. dorothy mcdonald turner is a strong, remarkable, cantankerous, stubborn, wounded and fascinating diva, whom thankfully has lived long enough to share her wisdom and experiences with all of us who adore her.

deciding whom to feature in this book wasn't really up to me. sometimes names would come to me in the middle of the night. sometimes, it was an accidental meeting, the way a person looked or a conversation i'd have with a total stranger. and, yes, i did go after people who either intrigued me or whom i admired. i was still trying to add some of those people hours before my deadline.

for the people who said yes, thank you all for being a part of this. i won't mention everyone's name here but you know who you are because you're in the book!

i would, however, like to single out miss rosa because she's no longer with us. she was a woman who grew up in nazi germany and was a patient at my dad's nursing home suffering from advanced alzheimer's. our bond began when she tugged at my jacket one day and said, "today's my birthday!" after she repeated it several times i thought about how lonely it must be for someone to celebrate a birthday in a nursing home with no family or friends. so, i headed down the street to kroger's and bought her a birthday cake and candles, took it back to the home and gave it to her. "birthday girls need birthday cakes," i said, fighting back tears.

her eyes, which were like these deep pools of complexity, welled up with tears. from her wheelchair, she motioned for me to come closer. she grabbed my ears and she kissed both my cheeks and thanked me profusely. i will never forget that moment. It was then i asked her the question for the book.

i also need to mention laurel lisa holloman. she is kind of the alpha and the omega of this project. she was among the first people i interviewed when i picked the book back up in 2009, and she was also the person who gave me the kick in the butt that i needed in 2012 to go ahead and "finish the damn thing." thanks ll.

i am eternally indebted to my rocks: charlene, bren, mary, bo and darcea. there is hardly a day that goes by that i don't reach out to one or all of you or vice-versa. you all are incredible blessings. thank you for your love, your patience, your sound advice and your guest bedrooms!

to my hampton institute ubiquity classmates (sorry, i gotta go with what's on my diploma!), the fact that i am including you in these acknowledgements speaks to the bond we share. it's been 33 years and you continue to embrace, support, inspire and uplift me as i do you. i'm madly in love with all of you.

to my l.a. crew: darlene, jackie, suzy, karen, denise, rrr, nico, jenny, trammel, red, lola, nala, gaby, diane and everyone else I have on speed dial, i am truly grateful for your advice, support, love and all those rides to lax! special thanks to jenny b. for that 11th hour save!

to my east coast mob: marilyn, marle, jackie, winnie, rhonda, mary s. and andrea, thanks for being the shelter during the storms.

to my bay area peeps: carlton, dara, cheryl, eva, ernie and even you lee, thanks for all the good times in the past and the ones to come.

to my global sisters: sonia, bea, haby, isabelle, sally and the entire mayhem crew, so much of this is due to your unrelenting marketing skills and support. cheers!

to my wyoming classmates and friends, some of you are represented on these pages, but the ones whose faces you won't see are all a part of this process. you all keep me grounded and i thank you for your unwavering and unconditional support of me. also, thanks to all of you who look after mom in my absence. that's what our 'hood is all about.

to my editors: venise wagner, darlene donloe and kathy buckley, thanks for donating your time to dot the i's and cross the t's.

to my launch party sponsors and supporters: the avenue, isabelle, mizz kris, zabrina horton (BET), karie dinardo (sony), jeremy levy (universal), elizabeth ninomiya (south african airways), kerry reed dunki-jacobs,

cheryl wood (ADEX), sheila petry, jackie burke (E!), amber smith, cheyenne smith, leroy hamilton, darlene donloe, rickey brown, jesse vasquez, roz stevenson and the good people who volunteered their services to make it a success, many, many thanks!

to my immediate family: mom, gary, linda, kim, jason and seby, thanks for the support. keep growing! to the extended mcdonald clan: thank you for just being you. we are so cool! my prayer is that we get together soon so we can prove it! let go and let god my peeps! to the bradfields, i hardly know most of you but i thank you for the gift of my father, the most honorable man i ever knew.

lastly, i know there are some people i left out, but it's late and my head aches. just know that my gratitude is eternal. your names are written across my heart.

miki turner

6dec 2012, los angeles

special thanks

this project was made possible only by the grace of god and the generous contributions of the people who supported my kickstarter campaign. while i can't mention all of you here—i do know who you are and where you live!—i will, however, list the backers below. i absolutely couldn't be more grateful to you all for believing in this book. thanks ever so much for making this journey so very, very special.

helena swiliniski, patty hoaglund, jen case, wendy stringer, bev hunt, isabelle van rolleghem, swetlana, nora martinez, carl rossiter, renee emery, ra, christiane, lisa king, james r. hall, lisa goddard, cindy gogluizza, natalie waite, kathy buckley, kristine javier, sara featherstone, debbie mccarthy, gemma agnew, grace scarloss, perle nunez, sonia alice labrousse, sally relph, kmst, sylvie leroy, mika, melissa, sonya singer, selma nicholas, jane birch, jadechoi, heather, rhiannon fionn, sara griffith adducci, secretgirl, heather snodgrass, milagros gomez and all the others who made it possible for us to reach our goal. you all have me deepest gratitude.

about the author

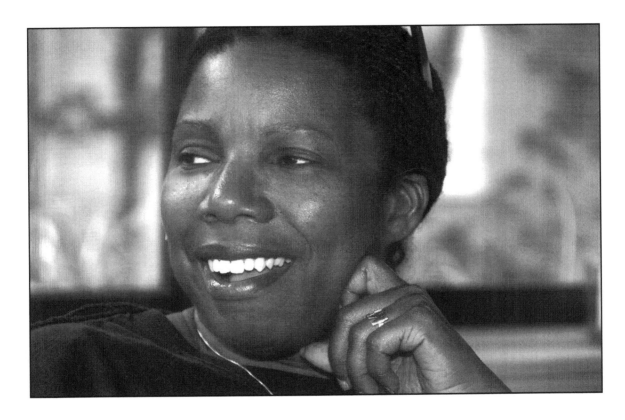

miki turner is an award-winning photojournalist who has loved the art of taking pictures since she was a child growing up in wyoming, oh. her first camera was a polaroid swinger and she's been upgrading her equipment ever since. a former sportswriter for the oakland tribune, espn.com and other newspapers, turner has also been a television and website producer, editor, videographer and still photographer covering sports and entertainment. her work has appeared in essence, ebony, jet, msnbc.com, aol.com, bet.com, tv one, bet and in several international publications. she is a member of the national association of black journalists, the television critics association and alpha kappa alpha. turner, who resides in los angeles, really felt an immense love for herself during the early '90s and that love affair continues to this day.

Made in the USA
Charleston, SC
18 March 2013